Victorian Narrative Painting

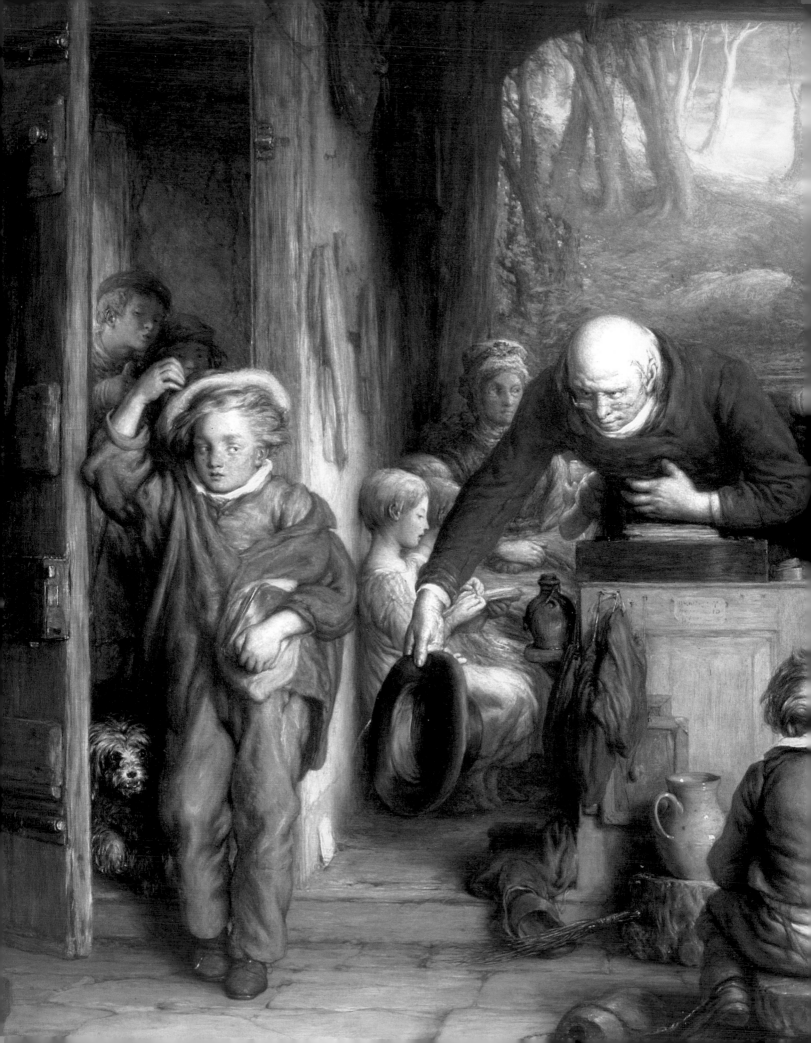

Victorian Narrative Painting

JULIA THOMAS

TATE PUBLISHING

Published by order of the Tate Trustees by
Tate Gallery Publishing Ltd
Millbank
London SW1P 4RG

A catalogue record for this book is available from the British Library

ISBN 1 85437 318 8

Designed and typeset by Caroline Johnston
Printed in Belgium by Snoeck-Ducaju & Zoon, Ghent

Front cover:
Philip Hermogenes Calderon, *Broken Vows* 1856
(detail, see p.57)

Frontispiece:
William Mulready, *The Last In* 1834–5
(detail, see p.18)

Back cover:
William Powell Frith, *The Derby Day* 1856–8

Contents

Acknowledgements

For frequent discussions about this book I am indebted to Neil Badmington, Caroline Darch, Christa Knellworth, Deborah Zeraschi and the staff at Tate Publishing, especially Sarah Derry and Mary Richards. The Leverhulme Trust helped me financially with a Special Research Fellowship that allowed me to work on this and other projects. I am also grateful to my parents Elizabeth and Michael Thomas, and Ivor Knight for a memorable trip to Torre Abbey that led to the inclusion here of *The Soldiers Wife*. I can never thank Catherine Belsey enough for her advice and support.

This book is dedicated to Stuart Pearson in memory of all those happy hours we have spent exploring art galleries.

RICHARD REDGRAVE
Country Cousins
detail (see p.71)

Introduction

THE BEGINNING OF THE STORY

In 1877 the novelist Henry James visited the Royal Academy exhibition in London and recorded his impressions in the *Galaxy*, an American journal. He wrote that:

> Standing ... with other observers, I was struck with the fact that when these were in groups or couples, they either, by way of comment, said nothing at all or said something simply about the subject of the picture – projected themselves into the story. I remember a remark made as I stood looking at a very prettily painted scene by Mr. Marcus Stone, representing a young lady in a pink satin dress, solemnly burning up a letter, while an old woman sits weeping in the background. Two ladies stood near me, entranced; for a long time they were silent. At last – '*Her mother was a widow!*' one of them gently breathed. Then they looked a little while longer and departed.

James uses this incident as a criticism of paintings that tell stories and spectators who try to 'read' them. According to him, this was yet more evidence of the 'irritating' narrative quality of British art in the mid-nineteenth century, an art that not only embodied the worst excesses of Victorian sentiment but attempted to embrace a textual dimension that was alien to it. Story-telling is not necessarily separate from the visual, however. Narrative images have, of course, been around for centuries and in very different cultures, from cave paintings and Greek and Roman friezes to the cartoons found on the pages of magazines and newspapers today. Indeed, there is a sense in which the very act of seeing is itself a type of reading, with the brain transforming random shapes and colours into signs that are familiar from the world.

In the Victorian period the narrative picture had a distinct identity that went against the grain of contemporary ideas about what a painting should be. It flourished in a period that had already denounced it. Juxtaposed with the lofty historical subjects and huge canvases favoured in previous centuries, these cabinet-sized paintings with their anecdotal, often domestic, scenes seemed relatively insignificant. The artist Benjamin Robert Haydon, an exponent of the grand manner, poured scorn upon the 'moderns' and was disdainful of any talented young painter who 'stooped

FRANK HOLL
Hush!
detail (see p.1)

9

to such things'. But there were other, more serious oppositions to the narrative picture. These had emerged in 1767 with the publication of *Laocoön*, a treatise on the arts written by the German dramatist and critic, Gotthold Ephraim Lessing. In contrast to earlier aesthetic theory that had stressed the sisterhood of poetry and painting, Lessing argued that the two arts had different qualities and limitations which meant they should not try to overlap or perform the function of the other. While poetry was temporal, capable of describing action and unfolding in time, painting was spatial, set in time and fixed in space, and more suited to the rendering of ideal beauty and the embodiment of a single, arrested moment. This distinction between the arts often meant that painting was regarded as the poor relation. Five years after Lessing's attack, and no doubt with it still ringing in his ears, the President of the Royal Academy, Joshua Reynolds, argued that the painter 'must compensate the natural deficiencies of his art. He

FRANK HOLL
Hush! and *Hushed* 1877
Tate

In a typical Victorian search for accuracy these pictures were painted at a fisherman's cottage on a summer excursion that Holl made to the Welsh coast in June 1877.

has but one sentence to utter, but one moment to exhibit.'

Despite the fact that *Laocoön* was one of the most popular texts in Victorian Britain, running through several editions, translations and reprints, it was art practice itself that was beginning to question those 'deficiencies' identified by Lessing and assumed by Reynolds. The idea that painting could not unfold in time, and was thus unable to assume a narrative function, came to be seen as a rigid rule imposed from the outside, and one that could therefore be broken. This was the conclusion reached by Richard Redgrave, himself a painter of stories, when he lectured to the Associated Arts' Institute in 1868:

> It would appear almost to be an axiom that the painter differs from the poet or the writer in having to select for illustration a single moment of time in the action of his story when it culminates in interest and effectiveness. Yet even this rule has been set aside, and

in some few cases with great success, proving that laws and rules are like crutches, of use to the feeble, but worthless and only encumbrances to the strong ...

Some painters ... have grouped together into one composition, incidents completely remote in time and place; almost, in fact, telling, the tale of a life on a single canvas.

The rule-breaking style of painting that Redgrave identifies here not only restored to art its ability to tell a tale, but was one of the most prolific pictorial genres in the mid-nineteenth century. In terms of popularity narrative pictures far surpassed images painted in the grand manner and they even went a long way to reversing traditional hierarchies. In May 1856 a review of the arts in the *Leader* stipulated that a painting 'rises in the scale of art in proportion as it is a story'. The success of the narrative picture can be partly attributed to the fact that it was the 'sister' not so much of

WILLIAM POWELL FRITH
The Road to Ruin, plate 1, 1878
Etching on paper
Victoria an dAlbert Museum,
London

Frith visited an undergraduate's room in Cambridge in order to get this picture right. The extent of the gambler's obsession is indicated by the fact that the group have been playing cards all night: one man watches the dawn breaking through the window, while another blows out a candle. The empty champagne bottle in the corner suggests a link between the two vices of drinking and gambling.

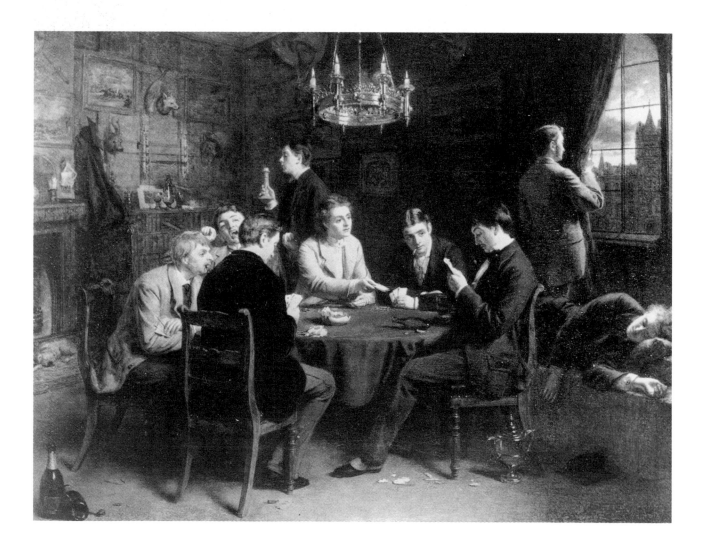

WILLIAM HOGARTH
The Rake's Progress, plate 1, 1735
Etching and engraving on paper
Tate

This scene depicts a young man, Tom Rakewell, inheriting the estate of a miser. It abounds in symbols and narrative devices that criticise both the dead man and his heir. While Tom is being measured for his mourning suit, he is interrupted by a mother and her daughter, who he has made pregnant (she holds a ring that indicates his broken promise of marriage). A workman makes a lucky discovery of a hoard of money in the coving of the ceiling and a corrupt lawyer steals some coins from a plate behind his master's back.

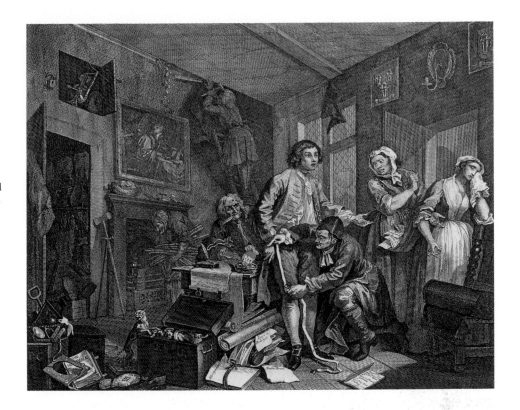

poetry but of the novel, with which it shared its story-telling devices. Many narrative paintings relied directly on texts to tell their tales, such as the often lengthy quotations that accompanied them in the exhibition catalogue or on the frame. Explanations were also provided by the titles. But the clearest analogy between these textual and visual genres can be seen in the pictorial stories, which replaced Redgrave's 'single canvas' with sequential images. These paintings span the century and its different artistic styles, and include diptychs like Frank Holl's *Hush!* and *Hushed* (pp.10 and 11), which tells the story of a baby's death, and William Powell Frith's series of five pictures, *The Road to Ruin* (see p.12), which shows the downfall and eventual suicide of a gambling man. Like so many narrative painters, Frith owes a great deal to William Hogarth, an artist who had gained in popularity since the beginning of the nineteenth century and whose use of symbolism, irony and plot was well known through his frequently published engravings. Frith acknowledged his particular debt to Hogarth's *The Rake's Progress* (p.13) by nicknaming his own series the 'gambler's progress'. With its homily against vice *The Road to Ruin* also followed the didactic sequences of the illustrator and engraver George Cruikshank, whose two series of eight pictures on the horrors of alcoholism, aptly titled *The Bottle* and *The Drunkard's Children*, appeared in 1847 and 1848.

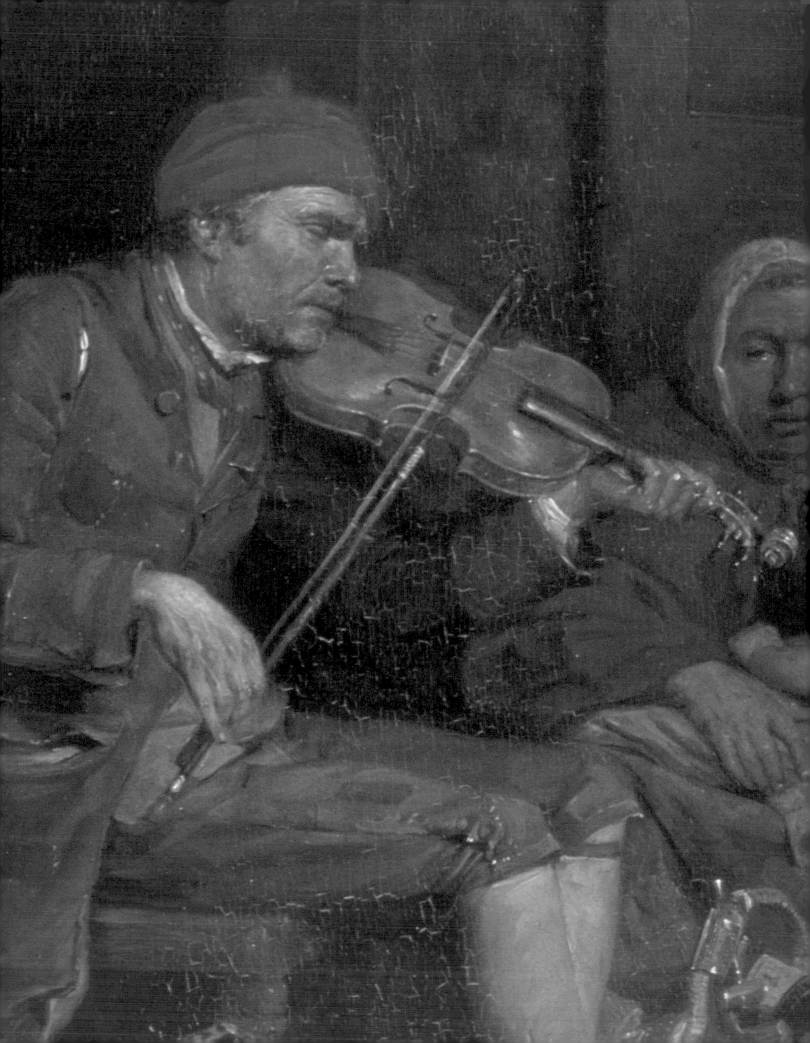

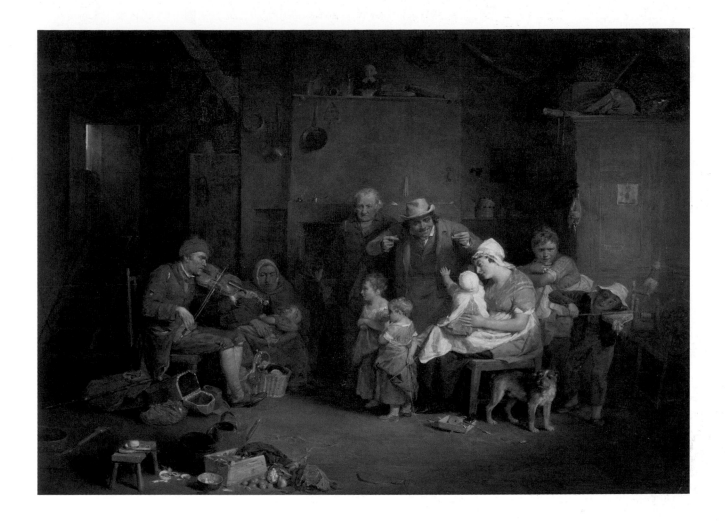

DAVID WILKIE
The Blind Fiddler 1806
Tate

A group scene like this allows for a narrative interaction between figures. As one man makes faces to a baby, who waves its arms in joy, other members of the audience are more subdued, especially an old man and woman, who stare into the distance, seemingly lost in the memories that the music evokes.

left
DAVID WILKIE
The Blind Fiddler
detail

Alongside the wealth of symbols and details that narrative painting and the novel shared, there was a mutual interest in physiognomy, where the face or outward appearance of a person was seen as an index of character. For the Scottish artist, David Wilkie (1785–1841), who was to a large extent responsible for the revival of the narrative picture in the nineteenth century, the aim of painting was not only to show the human countenance and form but to suggest the different emotions, feelings and personality traits that were written across the face and body. Wilkie drew on Dutch and Flemish genre paintings of the sixteenth and seventeenth centuries, depicting peasant scenes such as *The Blind Fiddler* (p.15) and *The Village Holiday* (p.16) with a tenderness and humour that, like their Dutch predecessors, were rich in narrative detail but renounced the bawdiness and sexual innuendo often associated with such pictures.

Wilkie's Irish counterpart was William Mulready (1786–1863), a painter admired by the Pre-Raphaelites for his brilliant colour and described by F.G. Stephens, an original member of the Pre-Raphaelite

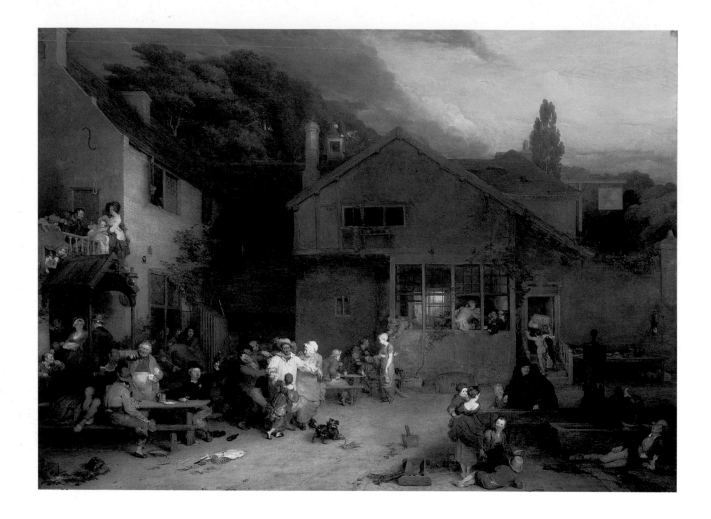

Brotherhood, as a 'poet'. His narrative art, like Wilkie's, was a further step away from traditional ideas about painting. Rejecting the search for ideal beauty, which artists such as Haydon argued 'should predominate in everything', Mulready asserted that the most important elements in a painting were story, character and expression. Nevertheless, while his paintings tell their tales, they also manage to retain an aesthetic appeal. *The Last In* (p.18) contrasts the schoolroom and its signs of discipline and learning with the attractive natural scene pictured through the window. The narrative here demands to be 'read', with the young boy sidling his way into the classroom, watched nervously by his friends on the other side of the door and the pinched old schoolmaster, who bows to him in mock respect. In front of the master, his leg tied to a log, a naughty child provides a sad omen of the punishment that awaits the latecomer, while under the window sits the school mistress, oblivious to the little drama that is unfolding before her.

DAVID WILKIE
The Village Holiday 1809–11
Tate

Both this picture and *The Blind Fiddler* (p.15) show the narrative import that Wilkie attached to the human countenance and body.

right
DAVID WILKIE
The Village Holiday
detail

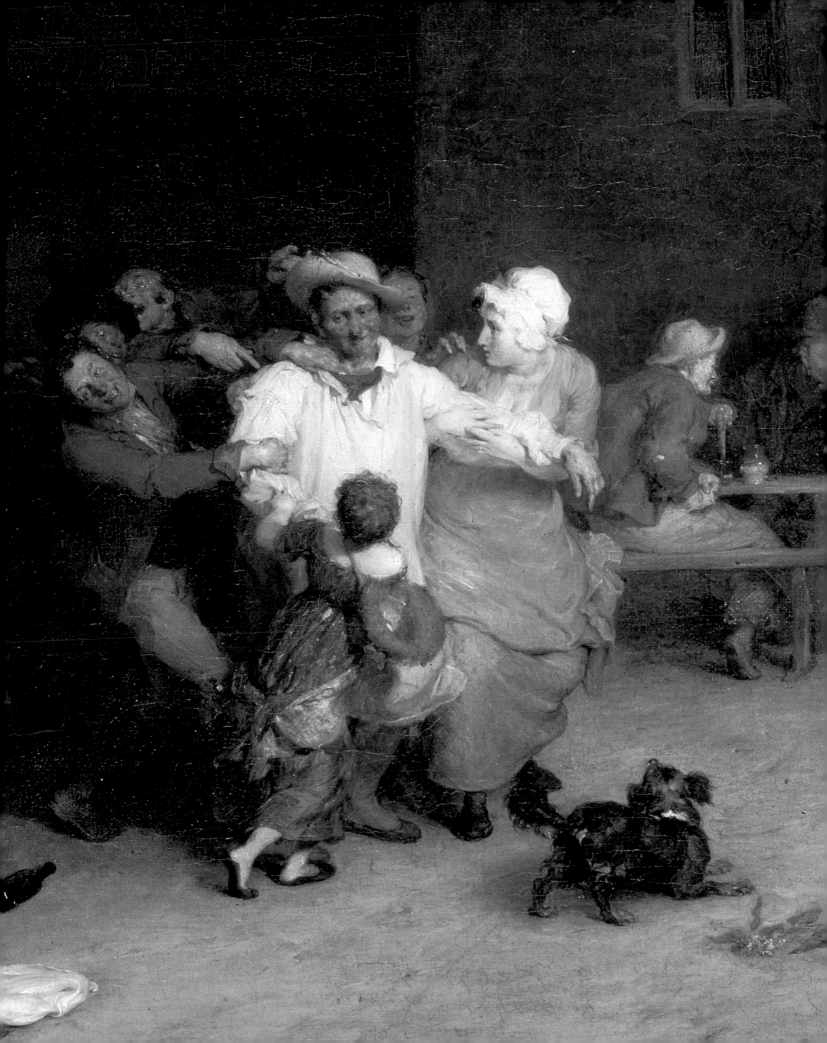

Mulready's subjects prompted many imitations and served to popularise the classroom as a setting for narrative art; some, like Thomas Brooks's *The Captured Truant* (1850), drew directly on this scene. But the most striking feature of this painting, which aligns it most closely with the complex narrative images that were to follow, is the fact that it leaves many questions unanswered and, in so doing, incites the viewer's desire to know more. Who, for example, is the strangely androgynous figure in white, who forms the apex of the diagonal line rising from boy to master? With its flowing white shift, it appears as a ghostly apparition, a fairy-tale character who has stepped in from the magical scene outside. Maybe this is a child who has suffered the same fate; or it could be the boy's sister, who gently reprimands him with a look of disappointment. And what of the two figures just visible on the right edge of the painting, one an old woman

WILLIAM MULREADY
The Last In 1834–5
Tate

The beautiful scene pictured through the window betrays Mulready's early work as a landscape painter.

taking a nap against the wall, and the other a mother and baby? Perhaps narrative paintings are unable to tell their story completely or perhaps they refuse to do so, leaving the viewer searching for the missing clue or resolution that never comes. The power of the narrative picture lies in this ability to evoke the spectator's desire, a desire that it always fails to satisfy.

TYPES OF NARRATIVE PAINTING

The term 'narrative painting' was not commonly used by the Victorians themselves. With their penchant for classification, pictures that told stories were described as 'scenes from everyday life', 'literary', 'genre', 'historical genre', 'anecdotal', 'domestic' or 'subject' paintings. My own broad categorisation of these pictures as 'narrative' stems, first, from the fact that I want to side-step the value-judgements that now accompany labels like 'genre' or 'domestic', and, second, because I want to emphasise that it is the story-telling dimension that unites these pictures, even in their differences. John Ruskin, the most influential Victorian art critic, came closest to this definition, calling such paintings 'poetical', a term that effectively stresses the link between picture and text, but seems surprising, considering the narrative painting's relation to the novel. Indeed, one critic complained that Ruskin's distinction was false and misleading because it privileged 'poetic' over 'prose-painters'. The use of this particular term does have important implications, however, because it sets Ruskin's ideas in relation, and opposition, to Lessing, who also concentrated on poetry and painting, and suggests that painting holds a status equal to an art that was commonly regarded as the most exalted. From the first volume of *Modern Painters*, which catapulted the young critic to fame, Ruskin asserted that painters could also be 'great poets' because they, too, were able to express noble ideas. The development of this thesis came with art itself, and by the time the third volume was published in 1856, Ruskin was able to point to the emergence of the very 'poetical' painting that he had anticipated over a decade before:

> a certain distinction must generally exist between men who ...
> would employ themselves in painting, more or less graphically, the
> outward verities of passing events – battles, councils, &c. – of their
> day ... and men who sought, in scenes of perhaps less outward
> importance, 'noble grounds for noble emotion;' – who would be, in
> a certain separate sense, *poetical* painters, some of them taking for
> subjects events which had actually happened, and others themes

from the poets; or, better still, becoming poets themselves in the entire sense, and inventing the story as they painted it. Painting seems to me only just to be beginning, in this sense also, to take its proper position beside literature, and the pictures of the 'Awakening Conscience,' 'Huguenot,' and such others, to be the first-fruits of its new effort.

Ruskin arranges 'poetical' paintings into three hierarchical groups according to the amount of invention needed in their construction. The highest type of picture is that in which the artist 'writes' his or her own story, followed by the illustrative painting that draws on a literary source, and then the historical painting, which depicts an event that has actually occurred.

Even Victorian history painting was strikingly different from the grand and heroic subjects that had preceded it, however. Edward Matthew Ward's *The South-Sea Bubble, A Scene in 'Change Alley in* 1720 (p.22) epitomises this shift with its combination of historical subject and narrative details that link it with Hogarth and range from the gibbet that has been painted on the door of the South Sea Company offices to the lady who offers her jewellery to the pawnbroker. The picture shows the imminent collapse of the value of stocks in the South Sea Company, which had taken on the nation's debts in 1720, but, although it is set in the past, its subject renders it very much a product of its own time. Such wild speculative excitement was familiar in the growing commercial empire of mid-nineteenth-century Britain and came to a climax in the crash of railway investments that occurred in 1847 when this picture was painted and exhibited.

Ward's narrative picture has as its literary analogue the Victorian history book and its emphasis on behind-the-scenes events and the personal lives of protagonists. But such pictures were outnumbered by another type of 'poetical' painting identified by Ruskin which drew on fiction, particularly the writings of Cervantes, Shakespeare, Goldsmith and Molière. So prominent were these illustrations that in 1855 a critic in the satirical magazine *Punch* wrote a mock review of a Royal Academy exhibition in which the Committee, deluged by several thousand such scenes, refused to show any from *The Vicar of Wakefield* and *Gil Blas*, or literary characters such as Slender and Anne Page from *The Merry Wives of Windsor*, Don Quixote or Sancho Panza. 'The Painters have therefore been thrown upon their own resources' commented the reviewer, 'and many of them in hunting for subjects have been greatly astonished to learn that there are

EDWARD MATTHEW WARD
*The South-Sea Bubble, A Scene in
'Change Alley in* 1720
detail (see p.22)

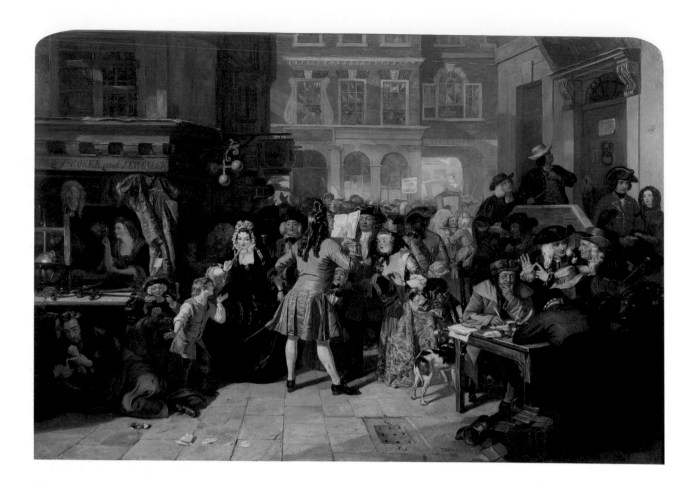

other books in the world besides those from which the above historical scenes are taken.'

At times, however, the distinction between narrative pictures that took their cue from literature and those whose subjects were invented was not so clear-cut. Richard Redgrave's *The Sempstress* (p.23), one of the first Victorian social realist pictures, shows a needlewoman working herself to death through the breaking dawn; the medicine bottles that line the shelf and the dying plant situated on the windowsill point to the tragic end of the story. But Redgrave, who knew nothing of the reality of the situation of seamstresses or the sweatshops in which they laboured, took as his source *The Song of the Shirt*, a poem by Thomas Hood, which had been published in *Punch* in 1843 and was cited in the exhibition catalogue:

> Oh! men with sisters dear,
> Oh! men with mothers and wives,
> It is not linen you're wearing out,
> But human creatures' lives.

EDWARD MATTHEW WARD
The South-Sea Bubble, A Scene in 'Change Alley in 1720 1847
Tate

Ward acknowledged his debt to Hogarth in another painting, *Hogarth's Studio, 1739 – Holiday Visit of Foundlings to View the Portrait of Captain Coram* (1863). It depicted orphans visiting the artist's studio in order to admire his picture of Thomas Coram, a sea-captain who had devoted much of his fortune to such children. See also Emma Brownlow's painting, *The Foundling Restored to its Mother* (p.47).

This is not to say, however, that this painting is, or could ever be, completely faithful to its literary counterpart. Thackeray regarded the image of the poor woman, bathed in her own spotlight and gazing to the heavens, as one that used crude visual symbols and failed to embody the humour and bitterness of the verse. But, despite such criticism, this painting did have an enormous impact, inspiring at least twenty other pictures of the same theme (like Anna Blunden's *For Only One Short Hour*, p.25) and playing an integral part in making the plight of the seamstress a familiar one. When Harriet Beecher Stowe, the writer of the anti-slave novel *Uncle Tom's Cabin*, visited Britain in 1853 she was criticised by *The Times* for having a dress made 'by poor, miserable white slaves, worse treated than the plantation slaves of America'!

RICHARD REDGRAVE
The Sempstress 1846
Forbes Magazine Collection,
New York

This is a replica of a subject painted by Redgrave in 1844. There are only minor changes between the two versions such as the magnifying glass on the plate that replaces a piece of bread.

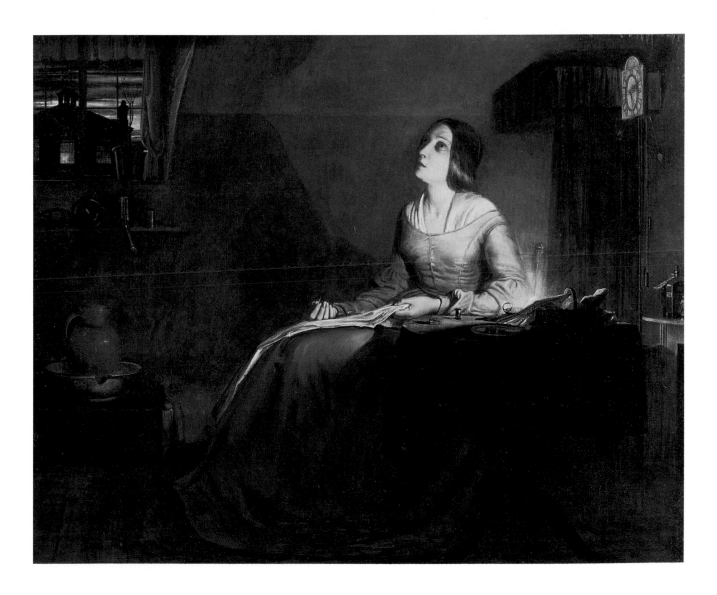

A 'poetical' picture of the highest order and one that Ruskin describes as taking its 'proper position besides literature' is William Holman Hunt's *The Awakening Conscience* (p.26). One of the most famous Victorian narrative paintings, it shows a moment of epiphany in which a familiar tune, played on the piano, prompts a kept mistress to realise the error of her ways. The picture was described in glowing terms by the reviewer in *Punch*:

> when MR. HUNT gives me such a picture as *The Awakened Conscience*, I feel that here is a man who comprehends some purpose of art in the world beyond pleasing my eye. I see a courageous determination to face one of the rifest evils of our time, and to read all of us youth a terrible lesson. Some tell me he has not succeeded – that his moral is obscure and his story unintelligible. I can only answer, that for my part I wish both were more of a riddle to me. I believe that the main reason why this noble work and MR. HUNT's other picture of *The Light of the World* have met with comparatively little sympathy is, that most of us have ceased altogether to look to pictures for any deeper or stronger meaning than the mind can catch at a look. We have no notion now-a-days of the painter preaching us a sermon.

For this particular critic, the main function of the narrative picture is to teach. Such images, indeed, were frequently moralistic, intended to incite lofty emotions with 'sermons' that were addressed especially to the lower classes. The genre marketed itself as the people's painting, an art that presented the middle and working classes as suitable pictorial subjects and instilled into them those values and ideals central to Victorian culture. Not only were the images themselves ennobling but the time required to view them meant that the working classes would be detained from other social evils. It was for this reason that some campaigners suggested that art galleries should open on Sundays. The artist, Henry O'Neil, asked 'whether a man is not better employed on a Sunday in looking at works of art than in lounging against the door of a public house, with a wistful eye on the Church clock, or in poring over sensational literature at home.' A review of the International Exhibition of 1862 argued that the didacticism of the narrative painting was the main reason for the progress of English art in the mid-nineteenth century: such pictures 'reconcile[d] aesthetic effects to ethical laws', remarked the critic; they always contained an 'awakened conscience'.

In *The Awakening Conscience* itself, however, there is less a 'reconcilia-

ANNA BLUNDEN
For Only One Short Hour 1854
Yale Center for British Art

This picture, which uses as its title a quotation from 'The Song of the Shirt', was featured in the *Illustrated London News* as a tribute to the poet, Thomas Hood, who had died in 1845.

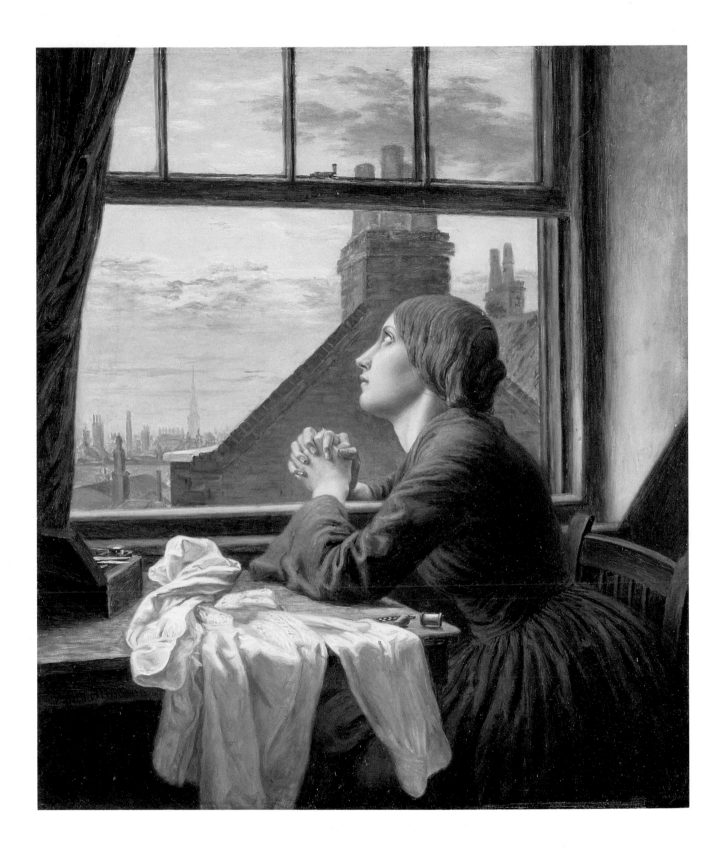

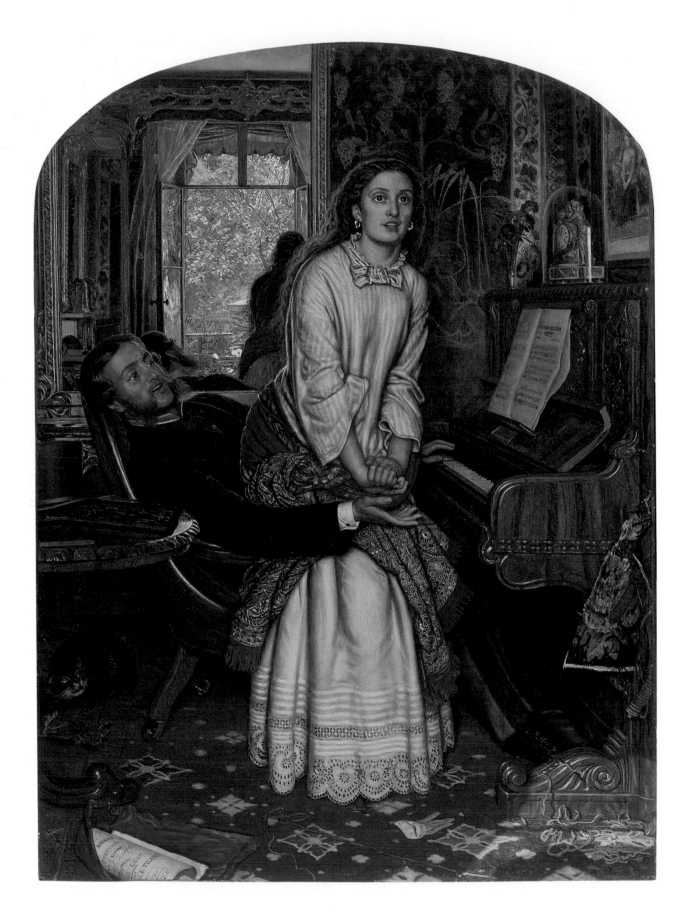

tion' of painterly techniques and moral issues as a subsuming of one by the other. By pleasing 'beyond the eye', the painting seems to stress the importance of subject over form. It is primarily there to be read and, as such, is dependent on an elaborate network of symbols, like the cat that attacks the bird under the table, the clock with its figures of Chastity and Cupid, and the music on the piano, Thomas Moore's 'Oft in the Stilly Night', a song about former innocence and present despair. These symbols spill out of the canvas and onto the frame where the marigolds, bells and star signify sorrow, warning and divine revelation. Such a picture cannot be taken in at a glance but demands that it be read over time, while its subject matter also points backward and forward in time, to a period of lost purity and an uncertain future.

READING THE NARRATIVE PICTURE

In January 1856, reeling from the excitement of having read Thackeray's novel *The Newcomes*, Edward Burne-Jones turned his attention to visual images and asked, almost despairingly, 'When shall we learn to read a picture as we would a poem, to find some story from it ...?' Perhaps the young artist need not have been so despondent, for it was precisely such a 'reading' that was encouraged by narrative paintings like Arthur Boyd Houghton's *The Volunteers* (p.28), where the viewer has to negotiate the relations between the figures, or panoramic pictures like Frith's *Ramsgate Sands* (1854), *The Derby Day* (p.30) and *The Railway Station* (1862). In *The Derby Day*, a painting of the famous race at Epsom, the spectator's attention is torn between the central figure of the child acrobat, tempted from his job by the sight of an impossibly large pie and mouth-watering lobster, and other incidents that crowd the canvas and fight for supremacy. Frith's rule was that all pictures should 'tell their own story without the aid of book or quotation', and he certainly seems to have achieved this aim here.

A painting like *The Derby Day* expects to be read like a book, a process suggested in one reviewer's description of the picture as a 'scene ... in four volumes'. The guard rail that was erected in front of the painting when it was exhibited in the Royal Academy in 1858 (which was, significantly, the first to be placed since Wilkie's narrative painting of 1822, *Chelsea Pensioners Reading the Waterloo Dispatch*) indicated not only its incredible popularity but the fact that the public had to linger in front of the canvas in order to 'read' it effectively. This caused considerable anxiety for the buyer, Jacob Bell, who wrote to Frith: The nature of the picture requires a close

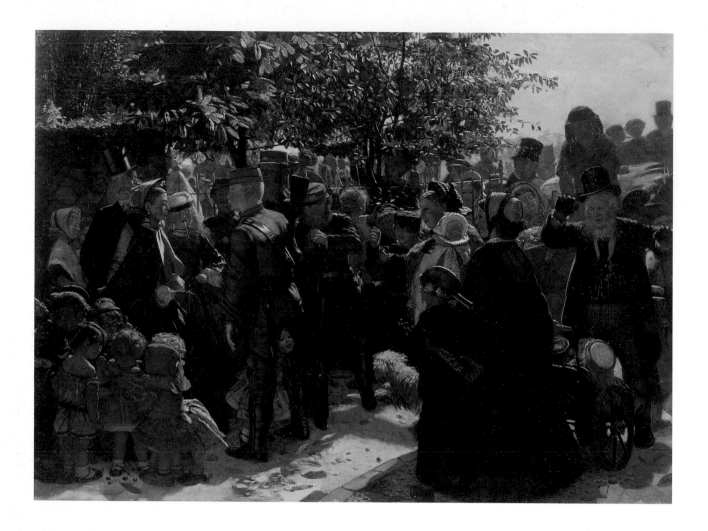

inspection to read, mark, learn, and inwardly digest it; and from what I have seen, I think it not unlikely that some of the readers will leave their mark upon it'. There are many stories of the exhibiting of *The Derby Day* that similarly testify to this mode of viewing. It was reported that a Pre-Raphaelite artist, shown the picture by Frith's wife, 'looked carefully over it, beginning at one end (it is on a long canvas), and going steadily across to the other, not uttering a word until he came to the end of the picture, when he said, "Ah, now I like that lady in the riding habit; good morning, Mrs. Frith, good morning!"' When another young painter viewed the painting, he began to whistle an air which he finished before he got half way through the painting. It was only when he completed the second rendition that he left the room, without a single word of comment to the artist. Such anecdotes suggest how the process of viewing narrative paintings is primarily a 'reading'; it is possible to get 'half way through' a picture as one could a novel and to pick up the clues as one goes along.

ARTHUR BOYD HOUGHTON
The Volunteers 1861
Tate

The Volunteer Movement began in 1859 amid fears of the plans of Napoleon III. This picture of the Home Guard is rich in dramatic detail, like the little girl who peers between the soldier's legs, and the old gentleman who has almost been run over by a push-chair. Houghton's pictures are easily recognisable from the characteristic round faces and huge eyes of his protagonists.

right
ARTHUR BOYD HOUGHTON
The Volunteers
detail

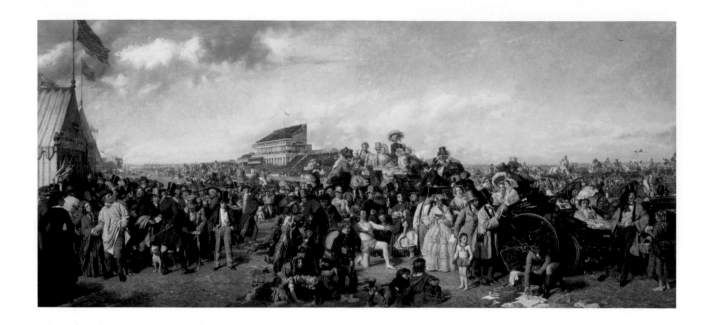

Indeed, the active role that this allows the spectator largely accounts for the popularity of narrative art. The viewer is no longer a passive recipient of the painting but a detective, whose job is to interpret the symbols, expressions and actions, in order to construct the story. Narrative painting depends upon and empowers its spectator, encouraging him or her to work at the image, to take a part in unravelling its meanings, and even to determine that it is to be 'read' in the first place.

As Burne-Jones also implies, however, this reading is not necessarily a natural process but a convention that has to be 'learned'. The interpretation of narrative paintings did not come easily, even for Victorian spectators, a factor testified to in the lengthy explanations that sometimes accompanied them and the fact that critics and artists were often forced to correct 'misreadings'. Ruskin, for example, wrote a letter to *The Times* that clarified the story of *The Awakening Conscience*, which, he complained, was being passed over in bewilderment. This necessity to explain narrative pictures suggests, in fact, that it was not quite the democratic art that it seemed. The symbolism used in such images could only be understood by an informed minority. It is possible that a working-class viewer, confronted with the music of 'Oft in the Stilly Night', would be unable to read the title, never mind gauge its significance. And this was assuming that he or she would even see the picture in the first place. Exhibitions of such works were primarily attended by the middle classes and, although technological advances in engraving brought pictures to a wider audience than ever

WILLIAM POWELL FRITH
The Derby Day 1856-8
Tate

Some colourful characters modelled for this painting, including the acrobat and his son, who were discovered by Frith in a Drury Lane pantomime.

before, many were not reproduced, intended instead to adorn the rooms of those who could afford to purchase them, the pillars of society, who, it was argued, least required their sermons. A critic in the *Quarterly Review* raised precisely this issue in regard to Hunt's *The Awakening Conscience*:

> Teaching by easel-pictures must at all times be very limited, for they can rarely reach those for whom the teaching is intended. Mr. Hunt's picture is a case in point. It will not be nailed up at Charing Cross, nor is it likely to fall into the hands of those for whose special warning it is intended.

It is no coincidence, indeed, that the growth of narrative painting paralleled the growth of art criticism. The critic came to prominence as one who could correctly interpret the image and teach the public how to do so. Thackeray, himself a keen art reviewer, noticed as early as 1844 that more journal space was being devoted to art reviews and that the critics were becoming more specialised, no longer hack reporters who would turn their hand to an exhibition of paintings as they would to a murder trial in the Old Bailey. In consequence, the power of the art reviewer itself became a subject for the narrative picture. One such painting, Thomas Edward Roberts's *The Opinion of the Press* (1859), shows a young artist distraught at an unfavourable review of his work. Ruskin, whose own criticisms were renowned for making or breaking artists, reviewed this picture favourably, but read it not as an attack on the critic's power but as a warning to artists to ignore what they read in the papers!

ART AND LIFE

The Royal Academy exhibition of 1854, which included *The Awakening Conscience*, was hailed decisively for bringing modern-day subjects to the fore. One reviewer commented that 'our painters are beginning to show an apprehension of this truth – that for Art to be a living thing amongst us, she must deal with subjects and themes from life'. Narrative paintings embodied this shift, or at least those 'poetical' pictures that invented their own stories, for these tended to be set in the contemporary world. *The Awakening Conscience* itself drew attention to the problem of prostitution, a theme that was also popularised in many novels of the time, while *The Derby Day*, exhibited four years later, was described as 'the picture of the age', a phrase that suggests its location both in and of its time. Spectators, it was argued, would empathise more with works that drew on the life

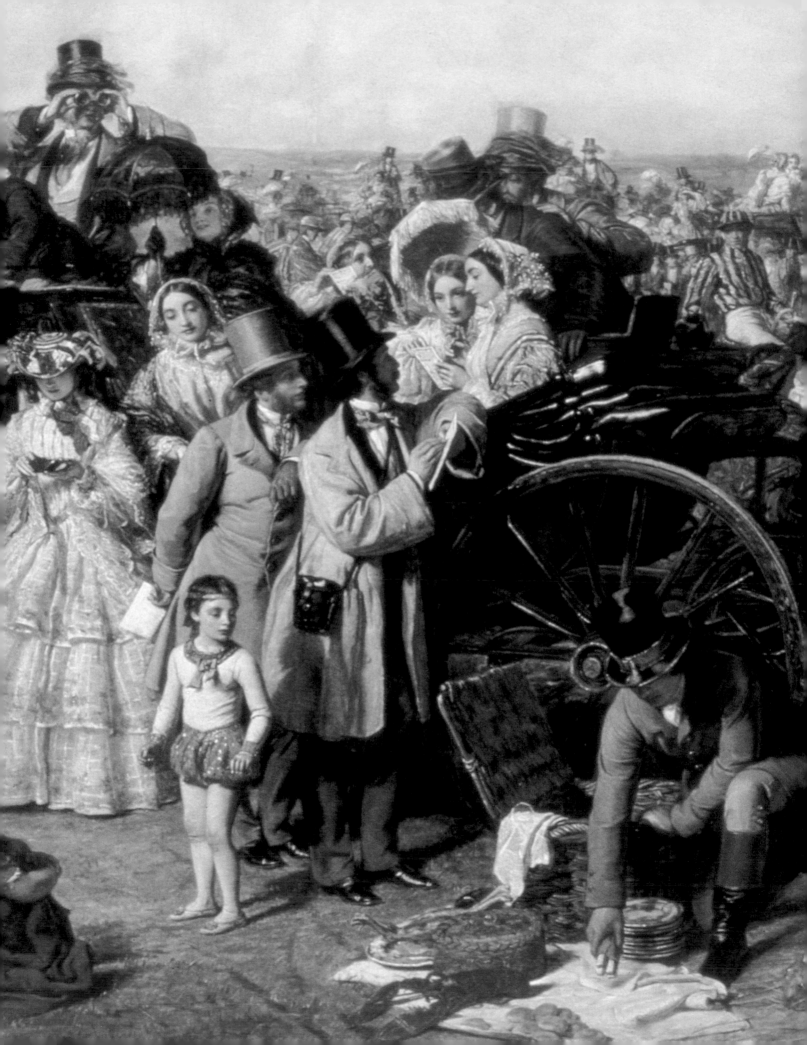

around them than they would with depictions of Charles II or Louis XIV. Ironically ahead of his time, Ruskin had eulogised the benefits of painting from the contemporary world a decade earlier with his characteristic blend of Christian and nationalist fervour:

> if we are now to do anything great, good, awful, religious, it must be got out of our own little island, and out of this year 1846, railroads and all: if a British painter, I say this in earnest seriousness, cannot make historical characters out of the British House of Peers, he cannot paint history; and if he cannot make a Madonna of a British girl of the nineteenth century, he cannot paint one at all.

According to Ruskin, not only should the past be subordinate to the present, but the present should itself be captured on canvas for the perusal of future generations. This is a move, of course, that effectively enforces the greatness of the age, turning the Victorians into heroes and 'Madonnas', and situating nineteenth-century Britain at the zenith of a progressive history. Such a 'historicisation', argued Ruskin, would have to include even those uglier elements, like railways, that had contributed to the success of the country, a proposition that was followed up in pictures that glorified labour and industry like Ford Madox Brown's *Work* (1852–63) and William Bell Scott's *Iron and Coal* (1856–61).

The aim of a truthful view of the world, based on a scrupulous representation of modern-day life, was characteristic of the Realist movement that was sweeping across the continent and coming to prominence in literature as well as art. The comments on this movement by the French painter, Gustave Courbet, often bear an uncanny resemblance to Ruskin's: 'I hold the artists of one century basically incapable of reproducing the aspect of a past or future century', he asserted. 'It is in this sense that I deny the possibility of historical art applied to the past. Historical art is by nature contemporary. Each epoch must have its artists who express it and reproduce it for the future.' Both Courbet and Ruskin contend that, although it might not be possible to paint the past or future, it is possible faithfully and even objectively to transcribe the present. Certainly, the narrative painting is still commonly regarded as documentary evidence, a mirror of the Victorian world. But if narrative paintings show contemporary subjects, it does not follow that they are a reflection of the way things really were. Their 'documentary' evidence is always problematic. Narrative pictures are primarily stories, not truths, and they aim for dramatic effect. This can be seen even in the social realist paintings that emerged in

WILLIAM POWELL FRITH
The Derby Day
detail (see p.30)

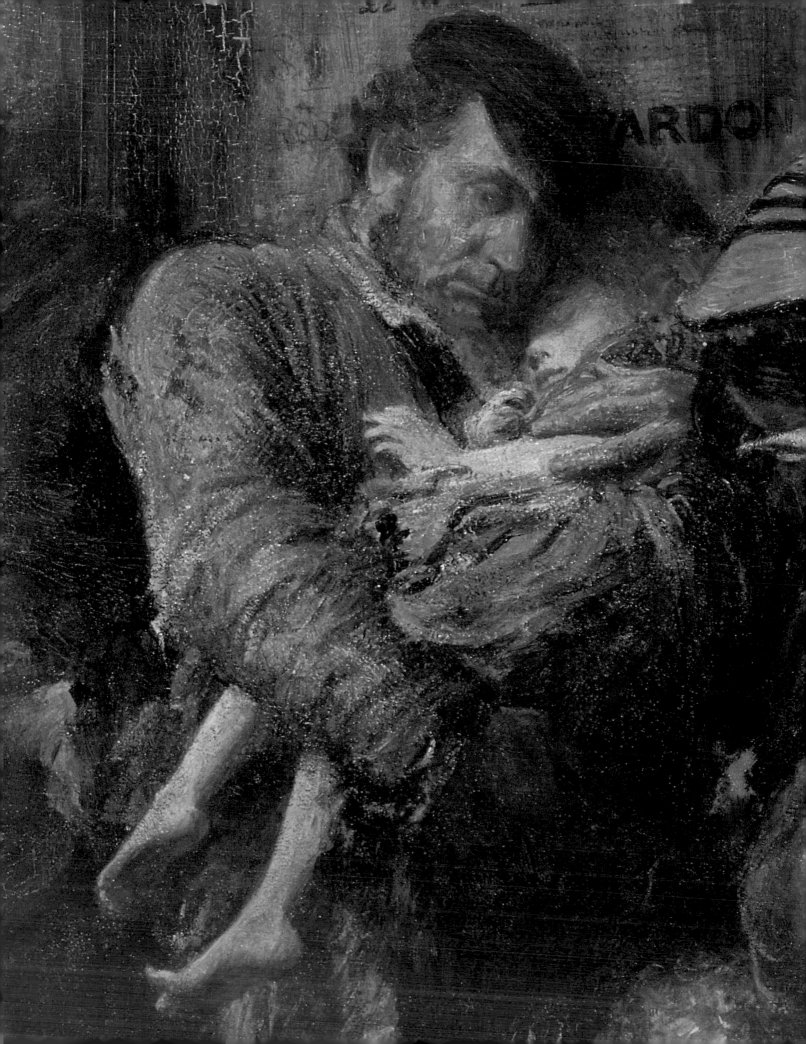

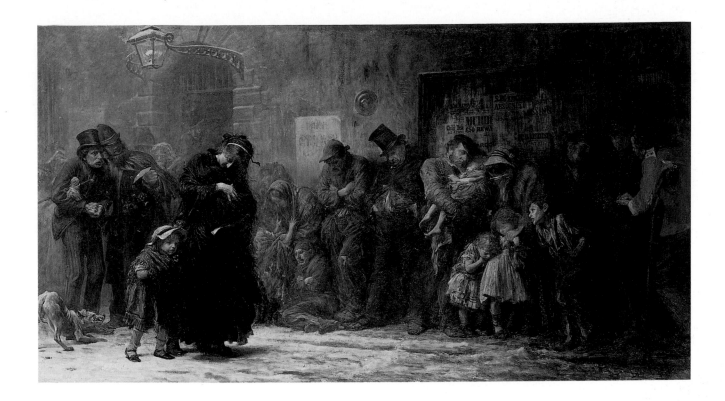

the 1870s like Luke Fildes's *Applicants for Admission to a Casual Ward* (p.35). This picture might well have drawn on the actual plight of the poor (Fildes used real vagrants for his models, albeit doused in disinfectant), but it employs a heavy-handed realism that fails to be totally realistic precisely because it announces itself as such. In its attempts to stir the social conscience, the picture strategically places at multiple focal points forlorn mothers, whose children cling to them for comfort and warmth. This elevation of the domestic ideal, even in the midst of despair, was likely to elicit the sympathy of even the most hard-hearted Victorian spectator.

Narrative paintings are perhaps closer to soap operas than to documentaries. We know that our life is not what we see on screen: there are just too many extraordinary incidents, too many deaths, too many love interests and entanglements for fiction to be 'realistic'. But perhaps it is not so much in what these pictures show that one can identify Victorian culture, but in what they leave out. Their limited canvas space means that not even panoramic paintings like *The Derby Day* can present the whole of society. There are choices to be made about what to include and what to exclude, and it is here that one can identify the Victorian discourses and ideologies of which the narrative painting forms a part. Paradoxically, however, the power of this genre lies in masking these ideologies, in con-

structing a view of the world that comes to seem real and true, whether this is a representation of the remorse of the prostitute, the distress of the needlewoman, or even a day at the races.

A NATIONAL SCHOOL OF ART

Ruskin's contention that the mid-nineteenth century should itself be reproduced in painting is intertwined with his concept of national identity: it is not so much the Victorian period *per se* that is to be pictured and glorified, but Victorian Britain (or Victorian England, the two signifiers of nation being virtually synonymous at this time). Ideas of what constituted the 'nation' were of particular relevance in an era of unprecedented colonial expansion and, as Ruskin's patriotism implies, these issues were certainly not divorced from the arts. Narrative painting was a space in which values could be propagated as British, a factor highlighted in the writings of the influential art critic Francis Turner Palgrave, who described the '*national* liking for pictures of children and lovers, household jests, and drawing-room tragedies'. Not only did individual paintings display dominant ideologies, but, taken collectively, as a genre, the narrative picture came to be regarded as specifically British, the embodiment of a national school of art. International exhibitions, which proved so popular at home and abroad following the success of the Great Exhibition of 1851, encouraged this construction by bringing together the arts of different nations and inciting comparisons between British and foreign schools. A review of the International Exhibition of 1862 in the *Art-Journal* described narrative painting of everyday life as

> emphatically English. And it is English, moreover, because we in
> England are daily making to ourselves a contemporary history ...
> because, unlike the nations enjoying long-established stagnation,
> Britain is a land of action and of progress, trade, commerce,
> growing wealth, steadfast yet ever changing liberty ... because in
> this actual present hour we act heroically, suffer manfully, and do
> those deeds which, in pictures and by poems, deserve to be
> recorded.

Although Victorian narrative painting had its roots in Dutch and Flemish art, these sources had been superseded, enabling the genre to become part of a nationalist project that defined British art and differentiated it from foreign genres. Even in a rare allusion to Dutch predecessors in Samuel

and Richard Redgrave's *A Century of Painters of the English School* (1866)
there is an assertion of the distinctiveness of the English manifestation.
Thus David Wilkie, the great exponent of the genre, showed 'how Dutch
art might be nationalised, and story and sentiment added to scenes of
common life treated with truth and individuality.' The Redgraves' goal in
this book is, in many ways, to unite the different countries that make up
Britain and to distinguish its art from the rest of the world. They achieve
this aim by identifying the common attributes of the Scotsman Wilkie,
Irishman Mulready and Englishman Charles Robert Leslie. The narrative
tradition to which these painters belonged, they contend, was 'so charac-
teristic of British art as to be wholly different from those of any other coun-
try'. The Britishness of narrative painting, however, was also discussed by
foreign critics. The French writer Hippolyte Taine, who visited the London

art galleries and exhibitions in the 1860s, came to the conclusion that story-telling was the most characteristic feature of British art and wryly asserted that some narrative painters had mistaken their vocation and should really have been writers instead.

Not only did such images constitute ideas of nation by being defined as specifically British, but they also functioned as consumer items, taking their place in a flourishing market where they were often exported as signs of Britain's expanding capitalist and colonial empire. Their relatively small size and frequent reproduction as engravings meant that they were high-ly portable, able to travel the world and propagate those English and Vic-torian ideals dominant in their subject matter, whether of domesticity, hard work or the rigid gender codes that pervaded society. Frith's *The Derby Day* was exhibited in America and Australia, while *The Railway Station* was shown in an exhibition in Philadelphia in 1876. Abroad, the pictures might serve as nostalgic reminders of the homeland to ex-patriots or to define the English way of life to those who might not be familiar with it. Part of the imperialist project themselves, they also represented the prob-lems of imperialist expansion, taking as their subjects scenes of emigra-tion or even colonial mutinies. Pictures like John Everett Millais's *The North-West Passage* (p.37) (a print of which was reputedly discovered in the hut of a South African Hottentot shepherd!) epitomised this Victorian exploratory zeal, capitalising on Britain's seeming ability to conquer the world. The North-West Passage, the sea around the north of the American continent which was thought to lead to the East, had remained elusive but tantalising to sailors like the one pictured here. The mood in this painting, however, is one of optimism. The fiercely patriotic subtitle 'It might be done: and England should do it' is juxtaposed with the proud display of the Union Jack and the picture of Nelson on the wall.

Narrative paintings, however, were not always required to travel too far. France, it seemed, was also susceptible to the amelioration that this genre had to offer. At the Exposition Universelle in Paris in 1855 French critics and artists, usually disdainful of British art, were reputedly pleasantly surprised, especially by the works of William Mulready. Richard Redgrave, who supervised the display of British pictures, recorded how the French concluded that 'only two schools then existed in Europe – "ours and yours". Other schools they said, "are founded on ours; yours is an original school".' The English press at the time was inundated with similar remarks that pointed to the difference of British art. For Redgrave this difference lay in the way the narrative picture favoured scenes of the household. Com-paring the battles and bloody deaths depicted in French painting with the

domestic stories told in British art, Redgrave wrote in his journal that British pictures

> more generally speak of peace, of a placid life, of home. Our subjects are undoubtedly of a less elevated, and of a lower and more familiar character in England, but they are works which a man can live with, and love to look on, obtruding no terrors on his sleeping or waking fancies. In fact, they seem to be what they are – the productions of a different race.

SCENES OF HOME

Redgrave's comments suggest that the construction of the narrative painting as a national art depended on its representation of the values of domesticity. The emphasis placed on private over public life was seen to embody Britain's national and racial difference. Not only did the narrative picture speak of the joys of family and hearth, but its cabinet size meant that it was itself intended to decorate the rooms of such homes rather than the grand corridors of a public building. 'In small rooms', commented one critic, 'small canvases are at once precipitated on the eye, which is flattered by prettiness and easy narrative. The painting of the present day is the light reading of the art, and light reading has ever been the most popular form both of art and literature.'

Because of this connection between domesticity and narrative painting, the focus here will be on images that relate to the family unit, that tell the tale of human life and the individual's relation to society. This does not imply, however, that the pictures always work to enforce domestic ideals or are ever simply 'light reading'. An interesting paradox of the Victorian narrative picture is that its very emphasis on insularity renders it most political. In this familial space, constructed as a haven from the outside world, 'exterior' forces, such as industry, poverty, prostitution or war, are merged and concentrated. The narrative painting carries within its tiny frame the burden and contradictions of a culture's ideologies. When catapulted into the space of an art gallery, the narrative picture undermines the private sphere of the home even as it upholds it, rendering its image open to scrutiny and its story public property.

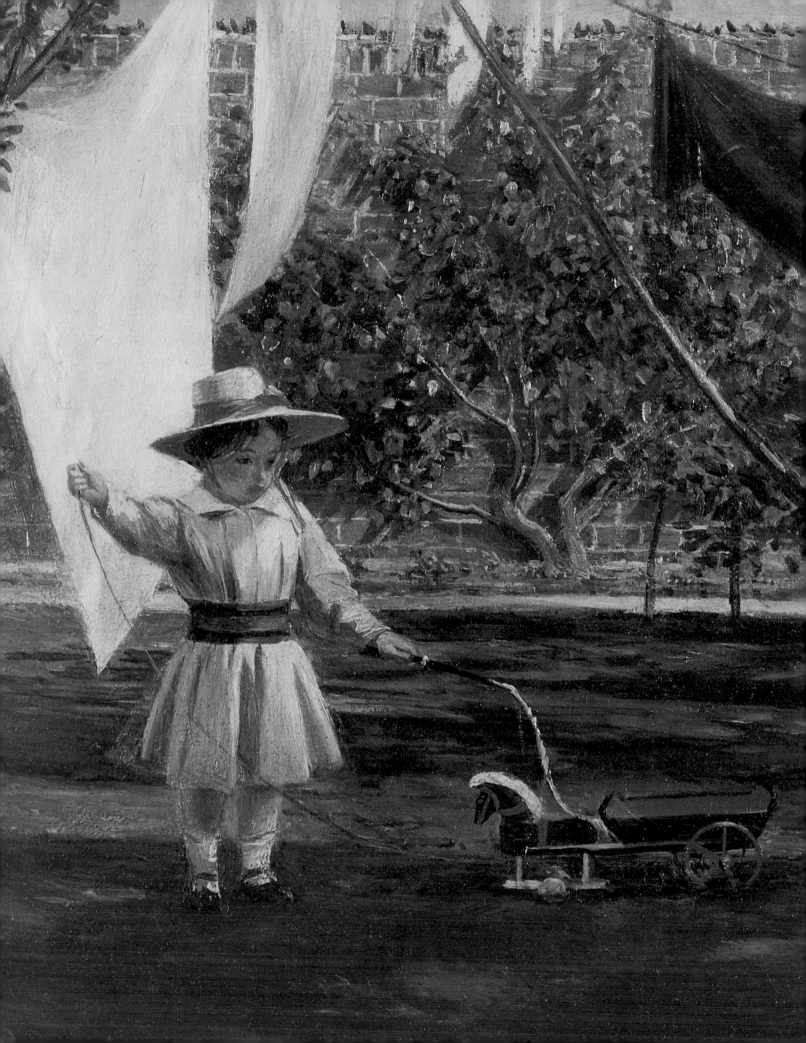

Childhood

The child sees everything in a state of newness; he is always *drunk*.

(Charles Baudelaire, *The Painter of Modern Life*, 1863)

Children occupy central positions in nineteenth-century narrative paintings, from golden-haired and rosy-cheeked little girls to cherubic boys blowing bubbles or playing with toy soldiers. They are most frequently set in or juxtaposed with an Edenic natural paradise, like the one seen through the window in Mulready's *The Last In* (p.18) or pictured in Charles Robert Leslie's *A Garden Scene* (p.42), which shows the artist's youngest son, still in petticoats, as he plays in the back garden of his Edgware Road home. Although this picture is set in the midst of London, the seclusion of the garden presents a scene that is self-consciously rural and idyllic. Childhood here is a time of play and sunshine, where the child is at one with nature: the trees provide an archway that shelters and protects him, the sun dapples the grass, and a light breeze gently blows the linen on the washing line – the perfect indication of a clean, well-ordered home. It is no wonder that such charming pictures appealed to the new middle-class buyers (this one was purchased by the mercantile collector, John Sheepshanks). Indeed, they reveal more about the needs of the adult spectator than of the child, evoking a nostalgia for games that the spectator can no longer play or for that vision of a bright new world that the painting can only momentarily capture. While they attempt to bring the viewers into the canvas, therefore, such images only ever set them at a distance; they are always tinged with a sense of sadness and loss. In Leslie's picture this pathos is poignantly evoked by the boy's isolation; he is framed in a fantasy world of coach and horses that even the artist is unable to enter. Here, the painter and spectator are set back from the scene, a factor emphasised in the perspectival play of the linen on a washing line, the convergent lines of which suggest its own and the viewer's concomitant distance from the child.

Such idealised images of childhood were also familiar in fiction of the period, which included angelic characters like Paul Dombey, Little Nell and Eva in *Uncle Tom's Cabin*. Their deaths, a comment on the high mortality rate of children in the period, provided a heart-rending drama that the narrative picture also utilised. In Henry Herbert La Thangue's *The Man with the Scythe* (p.43), a mother who has been collecting vegetables from

FREDERICK DANIEL HARDY
The Young Photographers
detail (see p.42)

41

her country garden has just discovered that her little girl has died. The child has all the trappings of an Eva, with golden locks, the sweetest of faces and a look of repose that suggests that she is at peace. The effectiveness of this painting relies on the fact that it rejects the often heavy-handed symbolism of earlier narrative paintings in favour of the effect achieved by sombre tones and lighting which add to the sanctity of the moment. The only symbol that obtrudes here is that which forms the picture's title, for, at that very moment, a man passes by the cottage gate on his way home from the fields, carrying the emblem of mortality, a scythe, on his shoulder. The naturalism of this scene, however, remains anything but contrived. The incident is presented as just one of those strange and tragic coincidences that haunt human life.

But the depiction of childhood in Victorian narrative painting is not necessarily as simple as some of the images suggest. The very construction of 'the child' has an ideological function: to propagate those family values

CHARLES ROBERT LESLIE
A Garden Scene 1840
Victoria and Albert Museum, London

George Dunlop Leslie, the artist's youngest son, is depicted here. He went on to become a painter and writer.

HENRY HERBERT
LA THANGUE
The Man with the Scythe 1896
Tate

La Thangue was an advocate of
plein air painting and had close
links with artists of the Newlyn
School, especially Stanhope Forbes.

that were central to the Victorians' idea of themselves. In this sense, the youngster has an adult role to play. Children are always in training to take up the social and gendered position that they will be allotted in later life. Leslie's little son, although dressed in the androgynous outfit popular for infants of both sexes, takes control of his horse, dragging it along with one hand and whipping it into action with the other, an indication that perhaps he is not as innocent of the ways of the world as he first appears. Indeed, this scene is in no way wild or unruly, but set within the angular borders of the pathway and the high wall that encloses the garden, with the suggestion that his games can only take place within the strict parameters set by his elders.

The apparent freedom of the child, then, is one that was strictly controlled, and this control was evinced in many aspects of Victorian family life, especially in education. The utilitarian views propagated by Jeremy Bentham and James Mill, and caricatured in the figure of Gradgrind in Dickens's *Hard Times* (1854), resulted in an especially rigid form of learning. When it came to educating his own son Mill put his theories into practice: John Stuart Mill learned Greek from the age of three and spent all of his youth wading through historical books, even learning science through texts rather than experiments. Although he maintained that he was allowed some leisure time, which was always solitary, holidays were strictly refused on the grounds that they might lead to a taste for idleness.

Many children, of course, did not receive any form of education. Whereas the middle classes were often instructed at home or, in the case of some boys, at private fee-paying schools, for the poor education was cursory at best, with Sunday Schools providing basic training in reading and writing. It was not until 1880 that education was made compulsory until the age of ten. Part of the reluctance of the government to take responsibility for education was that many families, and, indeed, the success of the industrial revolution, depended on cheap child labour. In 1839 it was estimated that just under half the factory workers were below eighteen. Even following Acts of Parliament in the 1830s and 1840s, which attempted to alleviate the problems of child labour by raising the age limit and reducing the hours that children could work in factories, some manufacturers exploited legal loopholes and continued to employ youngsters for long hours and in insufferably hot temperatures. Children in rural communities fared little better, living in overcrowded and damp cottages and often labouring on the land. For these children, there was no such thing as childhood. They were immersed from their earliest years in the adult capitalist world.

The narrative painter chose to ignore such scenes in favour of an abundance of idealised images. This marked absence suggests the extent to which such paintings were selective and distorted, unmatched even by fiction, which did, at least, contain its share of poverty-stricken and exploited children. It is easy to see how young workers might have been confused and even offended by the representation of childhood on offer in contemporary art. In his autobiography Joseph Clynes, a self-educated man who became Home Secretary in the Labour government of Ramsay MacDonald, seems to describe the very gap between such images and his life as a factory boy:

> I remember no golden summers, no triumphs at games and sports, no tramps through dark woods or over shadow-racing hills. Only meals at which there never seemed to be enough food, dreary journeys through smoke-fouled streets, in mornings when I nodded with tiredness and in evenings when my legs trembled under me from exhaustion.

GEORGE BERNARD O'NEILL
The Foundling 1852

Tate

EMMA BROWNLOW
The Foundling Restored to its Mother— an Incident in the Foundling Hospital 1858

Coram Foundation, London

Since the eighteenth century popular fiction had been inundated with tales of deserted babies. With their winning combination of sentimentalism and sensationalism, such stories often described the adventures of runaway children and the tragic and sexually-charged history of the mother's seduction and subsequent ruin. George Bernard O'Neill's *The Foundling* quoted directly from its literary source, George Crabbe's *The Parish Register*, in the Royal Academy exhibition catalogue, where it cited verses that described the meeting of village dignitaries to name a foundling. But the painting could as easily represent a scene from the opening of Dickens's *Oliver Twist*. Contemporary reviewers acknowledged these literary analogues, one critic calling the baby a 'little Tom Jones' and comparing the beadle to Mr Bumble. With its happy child, comic overtones, and unobtrusive symbols, it is not surprising that the picture had such favourable reviews. Much of its attraction, however, was not in what it showed but in the gaps in the story. In common with the tradition of literary foundlings, the painting makes a mystery of the baby's parentage, but, unlike *Tom Jones* or *Oliver Twist*, the enigma here is never resolved. The critic in the *Athenaeum* attempted to decipher this aspect of the tale in the complex relation between the figures, concluding that the father is the anxious-looking young man sat on the left, while the woman, who peeps behind him in the shadows, might also know something of the child's history.

There seems to be no such mystery in Emma Brownlow's pictorial narrative, which shows a mother reclaiming her child. This foundling takes its place less in a literary tradition than in the Victorian social world. Brownlow herself was brought up in the Thomas Coram Foundling Hospital where her father was secretary. He is pictured in this scene, along with some of the paintings that the hospital owned. Hogarth's *The March to Finchley* (1750) is in the centre, Lanfranco's picture of *Elijah Raising the Son of the Widow of Zarephath* and a tapestry of Herodias with the head of John the Baptist are on either side, while a view of the hospital hangs below, next to portraits of Ben Jonson and Shakespeare. Brownlow's own painting became part of this prestigious collection when it was presented to the institution by one of the vice-presidents.

The future for Brownlow's foundling is certainly more hopeful than that which seems to await O'Neill's baby (the little girl who acted as model in Brownlow's painting was herself reclaimed shortly after the picture was painted). O'Neill's picture hints at the power of the Parish Board of Guardians, which was set up by the 1834 Poor Law Amendment Act and was responsible for naming and rearing such babies. Most foundlings ended up in the workhouses this Act established, where it was estimated that over half the children were orphans. The popular account was that these babies had been born to women who had been wickedly seduced, a literary myth that was also fostered by the Thomas Coram Hospital, which gave preference to those cases in which some promise of marriage had been made to the mother or some deception practised upon her. However, it was more likely that the majority of foundlings came from poorer sections of the community, families in which there were already too many mouths to feed, or where the parents had died from disease or poor living conditions.

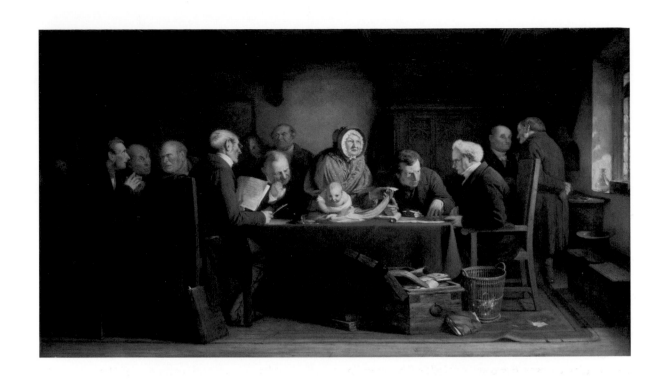

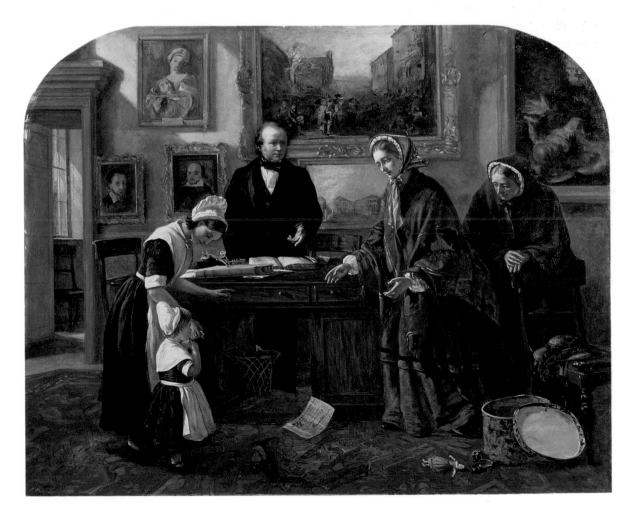

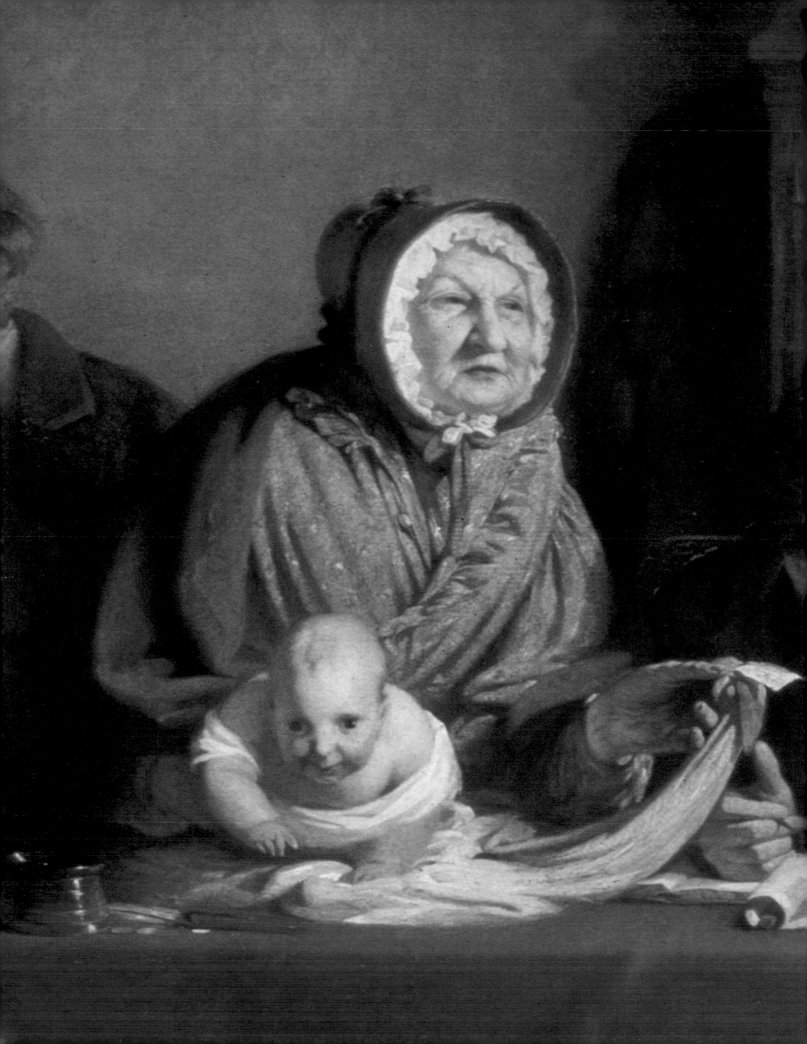

Perhaps O'Neill's baby would not be quite so cheerful if it realised the fate that awaits it: with only enough food to keep it alive in squalid, overcrowded housing, the child, when it is older, will attend the workhouse school and be sent to labour in the factories. Ultimately, however, both of these narrative pictures, with their beaming and spotless youngsters, child-friendly guardians and happy dramas owe more to fiction than they do to 'reality'. Even the seemingly historical basis of Brownlow's image does not detract from the purely narrative appeal of the scene. A critic in *Tait's Edinburgh Magazine* of 1858 described the picture as 'beautifully painted' and added that 'there is a depth of truthful and poetic feeling in it, which does as much credit to the heart and mind of the artist as the mere manipulation conveys to her artistic skill'. On a chair lies a child's hat, while a doll, a pair of shoes and the receipt that the institution issued to mothers, are discarded on the floor. The contents of this receipt were recorded by Charles Dickens in an article that he wrote about the Thomas Coram Hospital for his journal *Household Words*:

Hospital for the Maintenance and Education of Exposed and Deserted Young Children. The [blank] day of the [blank], received a [blank] child. [Blank] Secretary. Note – Let this be carefully kept, that it may be produced whenever an inquiry is made after the health of the child (which may be done on Mondays between the hours of ten and four), and also in case the child should be claimed.

Some aspects of Brownlow's story, however, like O'Neill's, remain indeterminate, such as the relationship between the younger and older woman, and the reason why the mother has abandoned her child in the first place. The woman's strikingly respectable and chaste appearance (notice the modesty and simplicity of her clothes and bonnet) presents both a resolution and a quandary. Could it be that the discovery of this child's existence might have led to her ruin? Can this apparently virtuous, middle-class woman really be sexually fallen? The painting leaves these possibilities open, presenting a female who has the potential to be both fallen and pure, a mother who at once upholds and strays from the Victorian ideal of womanhood.

GEORGE BERNARD O'NEILL
The Foundling
detail (see p.47)

SAMUEL LUKE FILDES

The Doctor 1891

Tate

In a humble cottage a little boy lies on two mis-matched chairs. His hand, outstretched and weakly clenched, seems feebly to cling on to the life that runs through it. Watching over the boy is a doctor, who has tilted the shade of a lamp for a closer and prolonged inspection, and whose benevolent, avuncular features are combined with a look that is studious and intent. The intensity of the scene is heightened by the presence of two figures who can just be discerned through the shadows in the top right: the boy's parents. Bathed in darkness, in stark contrast to the almost divine brightness of the doctor, the poor attire of the father stands out in the silvery glimmers of the dawn that breaks through the window. His hand rests on the shoulder of his wife, who buries her face on the table, unable to bear the scene.

The picture has all the potential for another sentimental episode in a child's illness and death, and, indeed, has been read in precisely this way. But the painting allows for a variety of responses. There is a sense, for example, in which the emotional intensity of *The Doctor* is not emphasised but banished to the shadows, where the parents await the news in darkness. The most prominent gaze in the painting is the scientific and alert one of the doctor, who watches his patient for any change. As the gaze of the doctor is the central focus, the spectator is encouraged to follow his lead. The picture does not so much encourage sentimentality as an examination. This scientific distance is particularly surprising considering the fact that the painting was inspired by the death of the artist's own son on Christmas day in 1877. Perhaps Fildes's personal investment in the subject was alleviated by an obsessive search for the painterly realism and authenticity so important to Victorian narrative painters, which allowed him to adopt the professional and objective gaze associated with the doctor himself. After sketching fishermen's homes in Devon, he went back to his studio, where he built a full-size replica cottage, complete with a window which he placed in front of

that of the studio in order to achieve the correct lighting effects.

The Doctor had been commissioned by Henry Tate, whose presentation of paintings to the nation formed the basis of the Tate's collection. The artist demanded £3,000, which he acknowledged was 'a very large sum to ask for a picture with so little work in it', but this was false modesty, for the canvas was unusually large for a narrative painting (over 5 by 8 feet), and Fildes acknowledged that the dawn lighting was particularly hard to achieve. The painting proved an incredible success. Crowds gathered to view it when it was shown in the Academy in 1891 and over a million engravings of it were sold. The reason for its popularity can be attributed to its subject matter: the artist's attempt to 'record the status of the doctor in our own time'. But the picture did more than simply 'record', and actually played its own part in increasing the respectability of the village doctor. At the beginning of the century the social standing of the doctor or apothecary was far below the handful of physicians who were based in London. Often working part time and poorly educated, the doctor suffered the added stigma of being regarded as a tradesman, who sold his medication and services. A number of Acts of Parliament in the mid-nineteenth century attempted to change this situation and make medicine a profession, in the sense of a distinct occupational and 'gentlemanly' group. But it was not until the end of the century, when Fildes began to paint his picture, that medicine really emerged as a modern occupation, with the agreement in the 1880s that all doctors should receive basic education in the areas of medicine, surgery and midwifery. To some extent, however, the transformation of the doctor's status depended not so much on his training as on how he was perceived by the public, and it is here that Fildes's picture so powerfully makes its mark. Even its humble setting has political implications, stressing the doctor's nobility and charity towards his poorer clients, and effec-

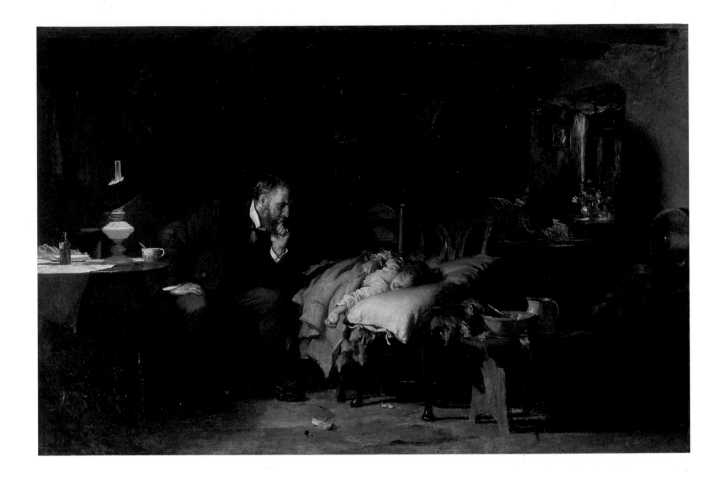

tively reversing the power relations of physicians at the beginning of the century, who relied on the patronage of their wealthy clientele. *The Doctor* both offers itself as the truth about doctors and actually produces that truth, with its atmosphere and lighting effects serving to make the construction of the medical man as a scientist and a gentleman seem natural and realistic. It is no wonder that the picture was greeted with such enthusiasm by the medical profession. In 1892 a doctor asked newly qualified students:

What do we not owe to Mr Fildes for showing to the world the typical doctor, as we would all like to be shown – an honest man and a gentleman, doing his best to relieve suffering? A library of books written in our honour would not do what this picture has done and will do for the medical profession in making the hearts of our fellow-men warm to us with confidence and affection.

FREDERICK DANIEL HARDY

The Young Photographers 1862

Tunbridge Wells Museum

Frederick Daniel Hardy was described by a contemporary critic in the *Art-Journal* as a 'deservedly popular' genre painter, who selected themes that were attractive and treated them 'with judgement, feeling, and good taste, and without the slightest tinge of vulgarity in their humour'. These qualities are epitomised in *The Young Photographers*, which shows the family of a country photographer making a camera of a sitting-room chair and 'photographing' an artistically arranged pile of books. The elder son, no doubt determined to follow in his father's footsteps, directs a younger sibling, whose head is hidden under a table-cloth that serves as the 'camera's' apron. Smaller children play the clients, while the mother, with a new addition to the family on her lap, bemusedly watches their activities while she trims some real photographs. As in all narrative paintings, it is the smaller details that bring this picture to life, like the hammer and chisel that lie on the rough wooden floor and the peeling wallpaper. Through the window, the children's game becomes an adult one as the photographer tries to interest passers-by in his wares, and in a backroom the studio can be glimpsed, with the real tripod, camera and a classical backdrop that awaits sitters.

From the 1830s, when photography was invented by William Fox Talbot in Britain and Louis Daguerre in France, its popularity had rapidly expanded, making it accessible to the lower classes and the more rural areas like the one pictured here. What is most striking about Hardy's painting, however, is the fact that it uses photography as a subject for art at all. Photography was in many ways useful to the artist. It made available to him or her images of paintings, sculptures or buildings that were in distant places or decaying, and served as a useful aide-memoire. William Powell Frith had employed the well-known photographer, Robert Howlett, to photograph the characters for *The Derby Day*, although he argued that his own pictures never turned out well under the camera. But, with its accurate rendering of detail, this new method was in direct conflict with contemporary realist painting. Charles Landseer, the elder brother of the animal painter Edwin, aptly nicknamed it 'foe-to-graphic art'. Certainly, the medium threatened portraiture, which for artists was a lucrative business, and it undermined narrative painting too, with the likes of the artist-turned-photographer, Henry Peach Robinson, arguing that photographs should also tell stories. Robinson had himself produced such narrative subjects from the 1850s, like *Fading Away* (1858), a photograph of the deathbed scene of a young woman which, in its title and subject, calls to mind a number of narrative paintings. The harsh reality was that the photographer presented in Hardy's picture had the potential to put artists like him out of business.

The status of this new medium in *The Young Photographers*, however, is far from transparent. On the one hand, the painting seems to offer a certain reconciliation between photography and painting. It implicitly stresses their shared characteristics, the realistic details that both strive for, and the fact that their apparent inability to present movement in time can capture the child in a Neverland of eternal youth. But it must not be forgotten that photography, at least in this picture, is at the service of painting. There might even be the suggestion that the colour, texture and comedy of this scene are precisely what the stilted black-and-white photograph that the woman holds is unable to show. The craze for photography, the image seems to imply, is a child's game, a thirst for novelty that in time will wear off, whereas the intrinsic and spiritual value of painting will last forever. As Hardy's fellow artist Henry O'Neil commented, 'When photography came first into notice, we were all fascinated by the marvellous accuracy with which every detail of form was rendered, and, with the new-born wonder of children, we forgot the absence of higher truths.'

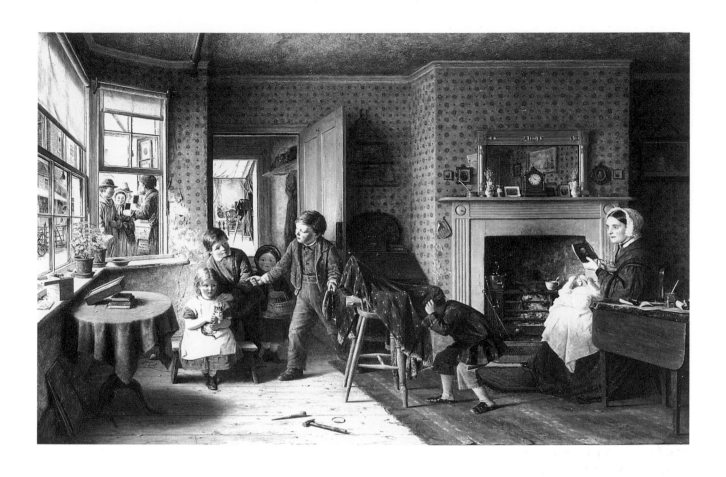

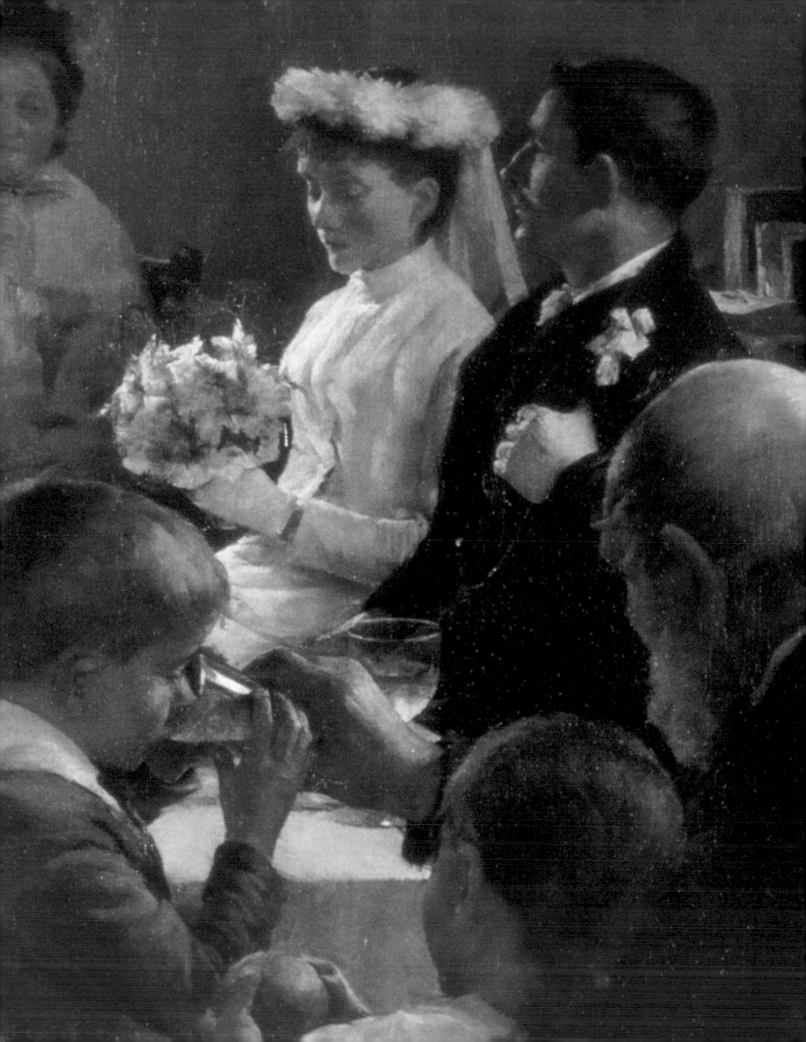

Love and Marriage

... he
Who truly knows the strength and bliss
Which are in love, will own with me
No passion but a virtue 'tis.

<div style="text-align: right">Coventry Patmore, The Angel in the House, 1856</div>

The popularity and conventional trappings of Victorian love stories like Patmore's *The Angel in the House* meant that pictorial images of such scenes were instantly recognisable and legible, relying less on elaborate symbolism and requiring little work on the part of the spectator. The Scottish painter, Thomas Faed, adds a story to what would otherwise be a portrait, and does so using only the body language of the protagonists, placing them almost back to back in *Faults on Both Sides* (p.56). Their positions are enough to tell of the stubborn couple's tiff: the man brings his crook thoughtfully to his mouth, the woman tugs with some frustration at a rag that she has tied around her hand, while both are watched by a rueful-looking dog, who seems eager for them to resolve their differences. Even in a more complex narrative picture like Philip Hermogenes Calderon's *Broken Vows* (p.57), which shows the agony of a woman who has discovered her lover making romantic overtures to someone else, the symbolism remains relatively low-key, with only the initials carved into the fence and the discarded bracelet on the floor serving as reminders of the tragic love affair.

The stark imagery of these pictures adds to their realism in a way that can never quite be attained by paintings that are laden with symbols. These pictorial love stories, however, did not so much comment on a reality that was outside them as played a part in constructing it. By sentimentalising and naturalising love, they romanticised the need to marry, providing a reason to tie the knot that obscured more pressing social ones, like women's financial dependence on men. And this was as true of the images that showed the tribulations and disappointments of love as of those that depicted its joys and happy conclusion: they spoke for what love was or was meant to be, for the power of love, and what should be suffered in its name.

But narrative pictures of love and romance were also highly problematic, and some, like William Orchardson's *Le Mariage de Convenance* (1883)

STANHOPE FORBES
The Health of the Bride
detail (see p.54)

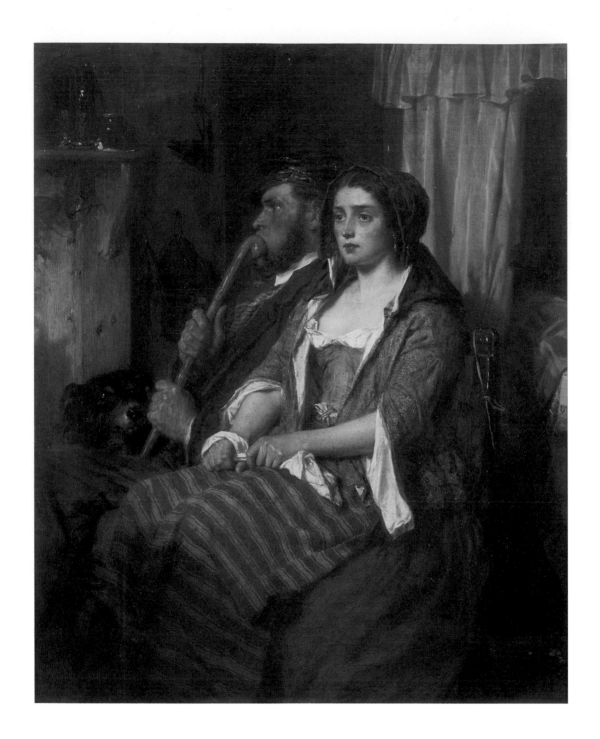

THOMAS FAED

Faults on Both Sides 1861

Tate

The people and countryside of
Scotland became increasingly
popular subjects for art in the mid-
nineteenth century, owing mainly
to the high profile enjoyed by
Scottish artists such as Thomas
Faed.

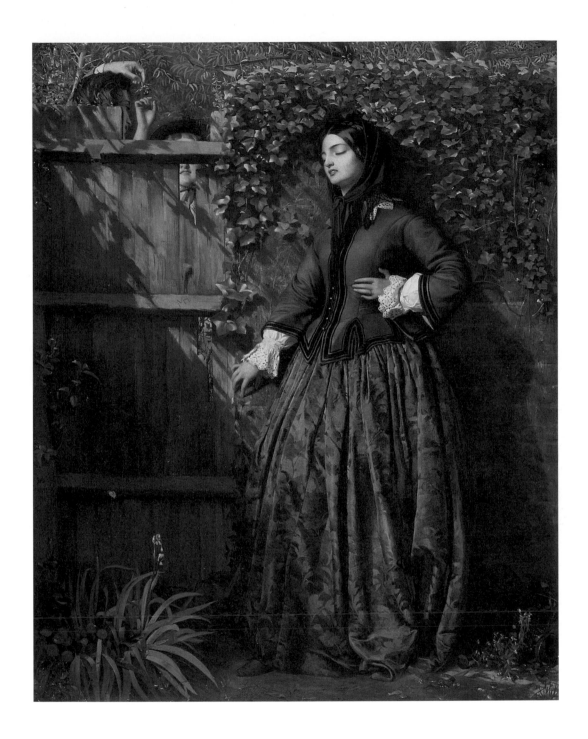

PHILIP HERMOGENES
CALDERON
Broken Vows 1856
Tate

Like so many Victorian narrative
paintings *Broken Vows* was
extremely popular as an engraving.

and *The First Cloud* (p.58), exposed the contradictions inherent in a culture that both encouraged companionate marriage and stressed the social elevation that marrying well could bring. Indeed, even the more conventional images of love presented their own difficulties by enforcing a romantic ideal that it was virtually impossible to attain. On his visits to London in the mid-nineteenth century the French commentator Hippolyte Taine was struck by the way that English women were influenced by such ideals:

> A young English girl will not marry unless through inclination; she weaves a romance for herself, and this dream forms part of her pride, of her chastity; thus many, and of exalted character, think they have fallen short should they marry without experiencing the enthusiasm suited to an absolute preference. To marry is to abandon oneself wholly and for ever.

It is no wonder that many women were bitterly disappointed in their experiences of love and marriage, for they did not so much 'weave' their own romances as have them woven for them in the public discourses of which the narrative painting formed a part. Taine, however, is eager to point out that this attitude is not sentimental but 'practical': far from dreaming of moonlight walks or outpourings of affection the woman longs to become the help and support of her husband, 'the useful partner' in his long journeys and difficult enterprises. But perhaps even this 'partnership' was hopelessly idealistic. Marital happiness was, of course, attained by many Victorian couples but it was not, as contemporary feminists were at pains to emphasise, the happiness that comes with equality. The fact remained that for the majority of the century the wife's subordination to her husband was not only encouraged but legally enforced: her body and even any children that she bore were his. Before the 1882 Married Women's Property Act the system of coverture, which subsumed a woman's legal identity with that of her husband, meant that any property that belonged to the wife was actually the possession of the husband, and this even applied to money she might earn. Taine's insightful comment that for English women, marriage leads to 'abandonment of the self' has more troubling meanings than the idea of a glorious self-sacrifice at the altar of love it seems at first to suggest.

PHILIP HERMOGENES
CALDERON
Broken Vows
detail (see p.57)

WILLIAM LINDSAY WINDUS

Too Late 1858

Tate

This painting was exhibited in 1859 with a quotation from Tennyson's poem *Come Not, When I am Dead*:

> If it were thine error or thy crime
> I care no longer, being all unblest;
> Wed whom thou wilt; but I am sick of time,
> And I desire to rest.

In the poem the narrator asks a former love not to mourn when he or she dies. The verse suggests that the couple have parted on bad terms. There are references to the lover's 'weak heart' and his or her refusal to 'save' the partner, but the exact reason for their parting remains elusive. Windus's picture retains the ambiguity of Tennyson's text and also refuses to fully account for the separation of the couple that it depicts. Perhaps the painting represents a tragic instance of a long engagement, which was often made necessary in the Victorian period because of the financial demands of marrying and supporting any number of children. This was a subject, indeed, that was becoming popular in art and makes an appearance in Arthur Hughes's famous painting of two careworn lovers, *The Long Engagement* (1853–9). The lines that Windus includes in the exhibition catalogue, however, allude specifically to an 'error' or 'crime' and seem to point to a more dramatic event, possibly infidelity or even seduction and desertion. Indeed, in his interpretation of the painting John Hadfield has remarked on the facial resemblance between the little girl and the dying woman. Whatever the case, it is true to say that this picture is another example of a narrative painting that refuses to fix its meanings.

When Windus was working on the painting, his friend, John Miller, wrote to the artist Ford Madox Brown that it told the story of a woman's 'ruined health and broken heart'. The female here does appear extraordinarily frail, even consumptive, with sunken eyes and only the barest spot of colour on her cheeks. It is no wonder that the man drops his walking stick and hides his face in the shock of the encounter. The painting, then, seems to show a (literally) lovesick woman, a familiar figure from literature of the period, where even the fiery heroines of sensation fiction are brought to death's door by a man's disinterest or desertion. It starts to become more apparent why the woman in Calderon's *Broken Vows* (p.57) clings not to her heart but to her side, as if she is physically as well as emotionally wounded by her lover's infidelity. This stereotype of the female victim of love was even given legal force in the litigation known as Breach of Promise, which, by enabling fathers to receive financial compensation for any injury to a jilted daughter's feelings, reputation or matrimonial prospects, gave the impression that there was a stigma attached to such women. And, to a certain extent, there was: the cult of the 'Angelic' female, who was pure, unsullied and passive, meant that many men were loath to commit themselves to a woman who was known to have already experienced a love affair.

The colours of this painting add to its story. The lurid green of the grass and young girl's smock, which is diluted into the near-transparent yellow of the woman's shroud-like dress, face, and the fields and sky behind, gives a sickly pallor to the whole canvas. In his review of the painting Ruskin linked the deathly state of the female protagonist to the painter: 'Something wrong here,' he wrote in his *Academy Notes*, 'either this painter has been ill; or his picture has been sent in to the Academy in a hurry.' He added that 'painting, as a mere physical exertion, requires the utmost possible strength of constitution and of heart' and that such 'puling and pining over deserted ladies, and knights run through the body, is, to the high artistic faculty, just so much poison.' Unfortunately, in the case of Windus, Ruskin's words proved remarkably accurate, and this artist became the embodiment of another popular stereotype: that of the withdrawn and emotionally fragile artist, who, like Chatterton (see p.85) and Keats, was pushed to the limits by harsh criticism. Following Ruskin's comments, and coupled with the death of his wife, Windus destroyed much of his work and abandoned professional painting for good.

STANHOPE FORBES
The Health of the Bride 1889

Tate

Reproduced today on countless wedding cards, Forbes's image was painted at an inn in Cornwall. The scene, which shows a sailor offering a toast to a nervous young bride, is a far cry from the raucous community occasions epitomised by Dutch genre pictures or even the happy wedding parties painted by Wilkie earlier in the century. With its larger canvas and sombre tones, this image is typical of late Victorian manifestations of the narrative painting, particularly those associated with the Newlyn School (named after the Cornish fishing village in which the artists set up their studios), of which Forbes was a leading member. The techniques of this picture invite comparison with *A Hopeless Dawn* (p.86), painted by another Newlyn resident, Frank Bramley. The lighting effects here are especially striking, with the afternoon sun that shines through the window illuminating part of the room and table but leaving the rest in deep shadow. The critic in the *Athenaeum* saw this as indicative of the picture as a whole, which, he argued, 'wants brilliancy of all kinds, from the illumination, colour, and actions to the expressions, which are too lugubrious'. There is certainly, as the reviewer seems to recognise, something uncomfortable about this picture, its restrained atmosphere and subdued colours, which, juxtaposed with the pensive expression of the bride, makes the promise of her future 'health' and happiness curiously unsatisfactory.

The uneasiness of the painting can perhaps be explained by its context, for Forbes's image is located, and plays its own part, in a culture in which marriage was coming increasingly under scrutiny. Debates about the institution came to the fore in the 1880s; fuelled by the women's movement and the campaign for suffrage, they emphasised the gendered power relations within marriage, enforcing the idea that it was a social institution in need of change. This reached a climax in the overwhelming public response to an attack on marriage written by Mona Caird which was published in the *Westminster Review* in 1888. When the *Daily Telegraph* invited its readers to respond to Caird's

article, it could hardly have anticipated the thousands of replies that came flooding into its offices. Many argued that marriage was failing because it stifled the intellectual development of men and women; others that modern marriage was little more than legalised prostitution, a patriarchal institution that despotically served the interests of men. According to Caird, the tyrannical power of the husband was validated by 'popular sentiment', which, no doubt, was influenced by the majority of narrative pictures as well as literature. *The Health of the Bride* is framed by these discussions. By making the nervous newlywed wife the focus of this image, the picture draws attention to the fate that awaits her, and loads its title with irony and foreboding. But the painting presents conflicting views of the marital relationship, refusing to offer an idyllic scene of wedded bliss or to condemn outright the institution. Thus, while it draws attention to the uncertainty of the bride's future, the painting in its very subject matter suggests that, despite public opinion to the contrary, marriage will continue to prosper. Indeed, the wedding ceremony had become increasingly popular throughout the nineteenth century, especially in working-class neighbourhoods, where church and civil weddings had all but replaced the common-law marriages still to a degree acceptable in the previous century. Moreover, the happy group that congregates around this bride is ultimately reassuring. On the bench and placed nearest the spectator, a man, perhaps himself a newlywed, steals his arm around the waist of his partner, while an older man hugs a little girl close and gives a young boy a sly sip of ale. This close-knit family unit suggests that there is more than superficial comfort awaiting the new bride. The problems of marriage were no doubt uppermost in Forbes's mind when he painted this scene in 1889, but were seemingly happily resolved, for it was in August of the same year that he married fellow artist, Elizabeth Armstrong, to whom he had been engaged for several years.

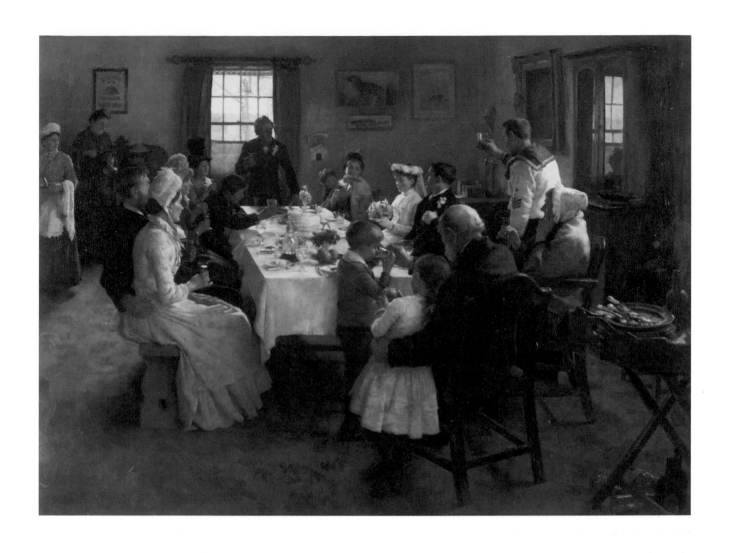

WILLIAM QUILLER ORCHARDSON
The First Cloud 1887

Tate

The First Cloud is a late Victorian reworking of the theme developed earlier in the century by Thomas Faed in *Faults on Both Sides* (p.56): the aftermath of a couple's argument. Orchardson, who was born in Scotland and enrolled at the Trustees' Academy in Edinburgh at the age of thirteen, would have been well aware of the narrative pictures of his countryman. But it is in this shared subject matter that the similarity between the two paintings ends. Faed's Highland cottage, with its simply dressed inhabitants, is replaced in Orchardson's picture by an opulent, aristocratic setting, while the closeness of the Scottish couple, which suggests the possibility of an imminent reconciliation, is undercut in the later painting in the great physical distance between husband and wife.

Orchardson's picture embodies what the writer George Moore called his 'vicious desire to narrate an anecdote', and the anecdote here is achieved on a grand scale reminiscent of the Victorian theatre, with curtains that frame the woman's dignified exit. She is watched rather doggedly by her husband, who already loosens his authoritative stance, his shoulders drooping and his hands falling awkwardly from his pockets. Everything in this picture works in opposition to itself and in a way that repeats the conflict between the couple. The subdued colours speak of emotional intensity, the transparency of the paint becomes almost tangible, space is claustrophobic, and the spectator, edged towards the furthest wall, becomes an integral part of the scene, the uncomfortable voyeur and third point in the triangle produced by the pictured protagonists. The woman's repressed anger is indicated in the simple but effective detail of her clenched hand and a posture that leans slightly towards the left of the canvas, in sharp contrast to the more naturalistic pose of her husband. Flanked on the left of the scene by a screen

that reproduces the colour of her dress, there is an ominous hint at the secrets masked behind the fragile facade of this relationship and the question of what this woman has herself been forced to 'screen'. But Orchardson's greatest achievement here is to tell the story not so much in symbols as in colour and atmosphere, in the long diagonal and swirling brushstrokes that break off sharply and absorb the mental turmoil of husband and wife. The calm cream exterior of the walls, furniture and dress is disturbed by yellowish tints and grey tones of shadow and light that merge in the void in which the woman disappears. In this silent moment the paint seems to resonate with the voices and accusations that have recently been expressed. The repressed emotions and the possibility of a further eruption are embodied in the volcanic orange glow of the table lamp that spills onto the wooden panels of the floor. Like the last embers of a fire, these rays mockingly draw attention to that symbol of the Victorian family, the hearth, which here is noticeably bare. Its emptiness adds pathos to the figure of the husband who stands in front of it in a futile attempt to warm himself.

When it was first exhibited in the Royal Academy, *Punch* produced a witty caricature of this picture, entitled 'The Painter and his Model' by W(ery) Q(urious) Orchardson, where the husband assumes the role of a painter (the figure was indeed modelled by an artist, Orchardson's friend, Tom Graham) and watches the departure of his wife/model:

Yes, you can go; I've done with you, my dear.
Here comes the Model for the following year.
(*To himself.*) Luck in odd numbers – Anno Jubilee –
This is Divorce Court Series Number Three.

The Home and its Outcasts

Every Englishman has a bit of romance in his heart with regard to marriage; he pictures a home with the wife of his choice, domestic talk, children; there his little universe is enclosed,

all his own.

(Hippolyte Taine, *Notes sur l'Angleterre* 1872)

The 'romantic' Englishman that Taine described did not have to work too hard to 'picture' this idyllic scene of domesticity. His home was his castle, a domain that was fortressed and enclosed from the outside world. While the man was obliged to participate in public life however, the woman was guardian of home and family, ideally a pure, chaste 'Angel in the House', who was sheltered from the corrupt influences of society. The reasons for these separate gendered spheres and the idealisation of the domestic space was voiced most eloquently by John Ruskin in a lecture that he delivered in Manchester in 1864:

> The man, in his rough work in [the] open world, must encounter all peril and trial ... But he guards the woman from all this; within his house, as ruled by her, unless she herself has sought it, need enter no danger, no temptation, no cause of error or offence. This is the true nature of home – it is the place of Peace; the shelter, not only from all injury, but from all terror, doubt, and division. In so far as it is not this, it is not home; so far as the anxieties of the outer life penetrate into it, and the inconsistently-minded, unknown, unloved, or hostile society of the outer world is allowed by either husband or wife to cross the threshold, it ceases to be home ...
>
> And wherever a true wife comes, this home is always round her.

Narrative pictures that attempted to represent such scenes were extremely marketable because, in Richard Redgrave's words, they could be 'lived with'. A painting of domestic bliss found its most suitable home in the real domestic space (a triumph, perhaps, of hope over experience!). While the majority of paintings showed happy families, however, others depicted the punishment meted out to those females who strayed from the domestic ideal. These subjects are highly ambiguous and problematic. They stand as a warning of the dire consequences that await those females who slip from the pedestal of purity, chastity and familial duty, and thus serve to enforce

THOMAS WEBSTER
A Letter from the Colonies
detail (see p.81)

67

Victorian values. But they also frequently represent the fallen woman not as a figure to be rebuked but as an object of sympathy. This paradox is present in Richard Redgrave's *The Outcast* (p.68) where an intransigent father casts a frightened young girl and her illegitimate child from the home. The villain of the piece is the father not the daughter; as she backs into the cold dark night, her brothers and sisters weep and beg for mercy. A letter, presumably written by the girl and pleading for forgiveness, lies discarded on the floor.

In *The Outcast*, as in so many images of fallen women, the girl's crime is represented and punished in terms of her eviction from her home; she must now fend for herself in the cruel world outside. However, in reality there was not such a sharp divide between the private sphere of the home and the public world. The home and family were of national and political import, providing a breeding-ground for the employers and employees of the future and a mechanism that instilled into children the gendered and

RICHARD REDGRAVE
The Outcast 1851
Royal Academy of Arts, London

This was Redgrave's diploma work for the Royal Academy. As with many narrative paintings, it relies on pictures within the picture to further its narrative. The theme of sexual crime is duplicated in the image on the wall, a depiction of a Biblical story that has been identified as either the woman taken in adultery or Abraham casting out Hagar and Ishmael.

right
RICHARD REDGRAVE
The Outcast
detail

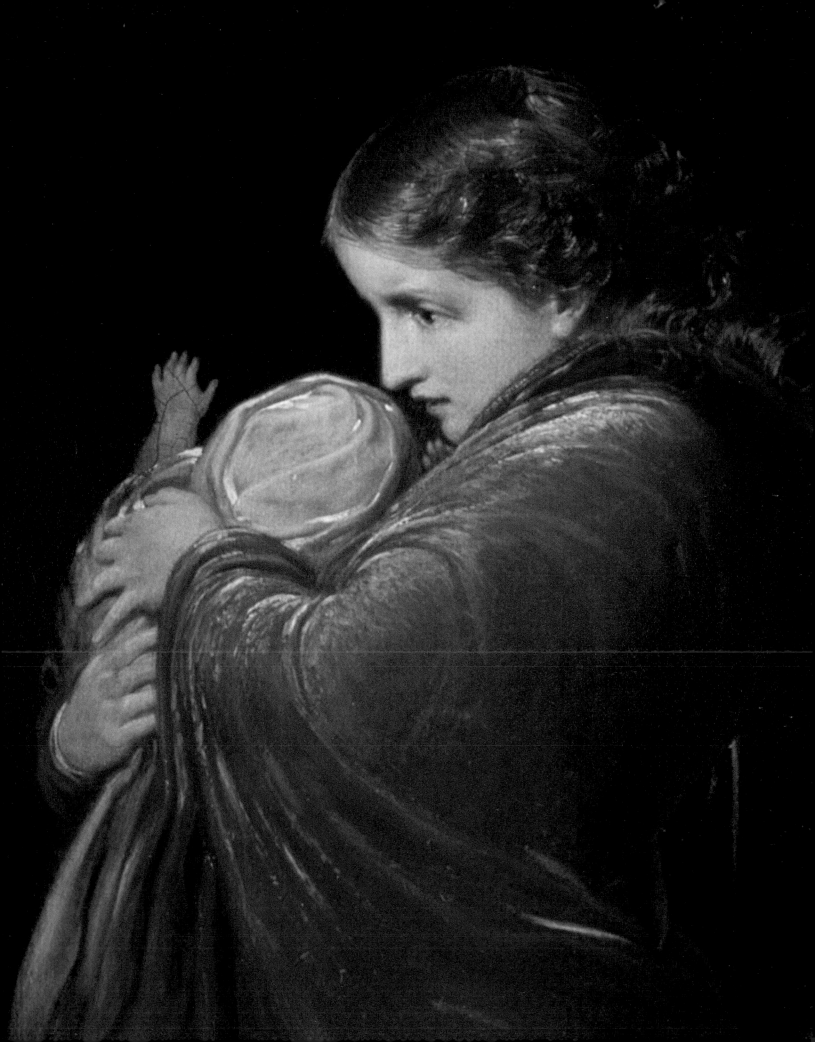

social roles that they should occupy as adults. Victorian feminists like Harriet Taylor and Barbara Bodichon attempted to show that the home was not divorced from the public world but a place where the husband had absolute control, not only over the body and property of his wife but over his children too. It was he who could decide how to educate them and he who almost invariably received custody in the case of marital separation.

Because it was governed by public laws and values, the home was never completely private, and it is this that the Victorian narrative painting exposes. In such images the domestic space is a vehicle for discussing what occurs 'outside', whether this is in terms of the effects of war, emigration, industrialisation or class. This is indicated in another of Redgrave's paintings, *Country Cousins* (p.71), where town residents are visited by relatives from the countryside. The gentleman sitting in the armchair looks particularly discomfited by the experience and uses his newspaper to screen out his guests. Realising this slight, the country daughter tries to stop her mother parading a little boy, adorned in all his Sunday finery. The picture is essentially a comic one of family life but it also deals with social problems. The onset of industry in the towns and cities had led to an increasing social, geographical and familial divide. Not only has the extended family all but disappeared by the mid-nineteenth century but for the wealthier town relatives the country cousins are almost an alien race. Their contrasting lifestyles and the object of the poor cousins' visit is indicated in the illustration of the story of Dives and Lazarus that hangs above the fireplace. This parable recounts how Lazarus, a cripple who ekes out a meagre existence by begging outside the luxurious house of Dives (the Latin term for 'rich man'), eventually dies and is taken to heaven while the wealthy Dives goes to hell. Redgrave's picture, by addressing these social issues, seems to anticipate Thomas Hardy's heroine, Tess, who over forty years later, attempted to claim kinship with her wealthier town 'cousins', and with tragic consequences.

RICHARD REDGRAVE

Country Cousins ?1847–8

Tate

The human drama is cleverly
mirrored by the dogs in the
foreground, with the mongrel
bowing to a pampered-looking
pooch, who steadily ignores it.

JOHN RODDAM SPENCER STANHOPE
Thoughts of the Past 1859

Tate

The 'fallen woman' was a familiar figure in Pre-Raphaelite paintings like William Holman Hunt's *The Awakening Conscience* (p.26) and Dante Gabriel Rossetti's *Found* (1854). Stanhope, who was a follower of the Pre-Raphaelites, painted this scene in a studio below Rossetti's in Chatham Place, Blackfriars, that overlooked the River Thames. The river is itself is an integral part of this picture, drawing on the literary convention of the prostitute who drowns herself as the only way out of her situation, an image that was popularised in Thomas Hood's famous poem *The Bridge of Sighs*, which describes, with some relish, such a woman being dragged from the water. The room in which Stanhope's heroine stands similarly tells her story, from the cracked windowpane and torn curtain to the spindly potted plant that strives towards the light. The scene bears a close resemblance to Dickens's *David Copperfield* (1849–50) where the seduced Emily, herself closely associated with the river, finds refuge in the lodging-house of her fallen friend, Martha. This building is also described as in a state of disrepair and faded grandeur, with flower-pots that decorate cracked and glassless windows. Emily's tale has a happier outcome than that of the female depicted here, however, for her refuge has saved her from the ultimate ruin of prostitution.

Dickens, who helped to establish a shelter for fallen women, played a part in making the 'Great Social Evil' a public issue. The problem of prostitution was also debated when the Contagious Diseases Acts were passed in 1864, 1866 and 1869. These acts, which aimed to prevent the spread of sexually transmitted diseases in garrison towns, stipulated that any woman identified as a prostitute was to have fortnightly examinations and, if infected, could be detained in hospital for as long as nine months. While criminalising the woman, the acts allowed her client to get away scot-free. In his documentation of mid-nineteenth-century city life, *London Labour and the London Poor*, Henry Mayhew also devoted considerable space to the prostitute, formulating a list of different types that throws the Victorian obsession with classification into a whole new light. The woman pictured by Stanhope, who lives near the Thames, might fall into Mayhew's category of a 'Sailors' Woman', but her lodging-house suggests that she is more likely to be a kept mistress, though not in the same league as the female depicted in Hunt's *The Awakening Conscience*. This is further emphasised in the presence of a man's glove and walking-stick on the floor and the loose coins on the dressing-table.

Stanhope's representation of a woman who is momentarily caught up in thoughts of past innocence might have been inspired by Rossetti's *The Gate of Memory*, a watercolour painted in 1857, that depicts yet another fallen female, who ruefully watches children at play in an alleyway. Such depictions of the prostitute construct her as a remorseful victim and thus lessen her threat to the middle-class family and its feminine ideal. But they also mean that, far from a figure to be condemned, the embodiment of 'Social Evil', she appears as an object of sympathy. Ironically, however, this stereotype of the sorrowful prostitute was undercut by the actual fallen women who modelled for the Pre-Raphaelites. Fanny Cornforth, reputed to have been one of the models who sat for Stanhope, thoroughly enjoyed her various sexual encounters and propositioned Rossetti while she was street-walking. She seems to have been the influence for his poem about a happy-go-lucky prostitute called Jenny who was 'Fond of a kiss and fond of a guinea'. But even in these verses the characteristic Victorian sentimentalism makes its appearance: Jenny, like Stanhope's heroine, is, ultimately, a 'Poor flower left torn since yesterday / Until tomorrow leave you bare'.

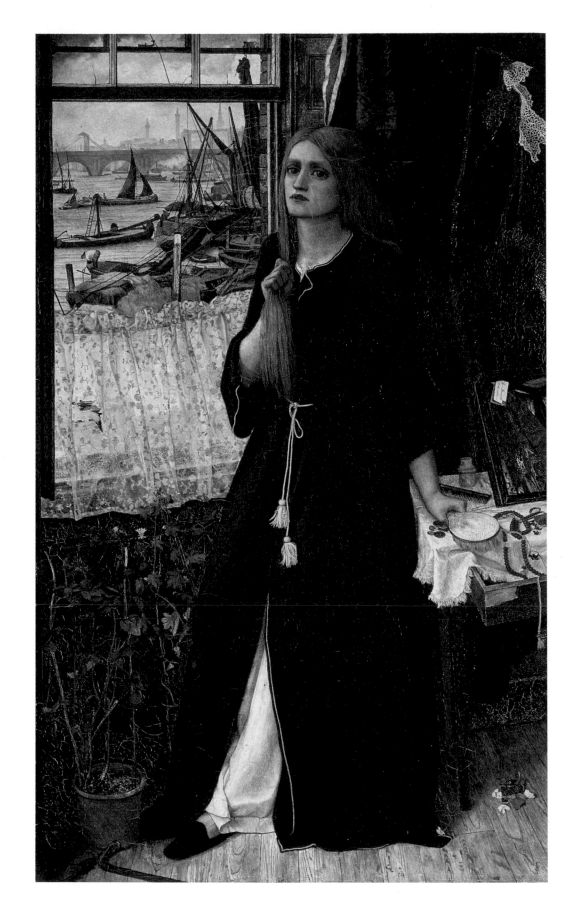

ROBERT BRAITHWAITE MARTINEAU
The Last Day in the Old Home 1862

Tate

Perched on the edge of a table, his foot nonchalantly resting on an antique chair, a young man toasts an ancestor, whose portrait gazes sternly from the wall. He is joined in this venture by his son, whom he casually embraces with an attitude of paternal care and friendly solidarity. Father and son are surrounded by reminders of the prestige and age of the family to which they belong, from the medieval tapestries and triptychs that decorate the room to a suit of armour that stands proudly in the corner. Next to this happy group, in front of a bay window that overlooks the property's grounds, are the female representatives of the family: the grandmother, wife and daughter.

This picture, as it first appears, seems to extol the virtues of family life, and there is a sense, indeed, in which it does perform this function – but in reverse, by showing the disintegration of such values. For if one looks more closely at the objects in the room one can discern the lot numbers with which they are ticketed, while, through the open door, a man prepares the last items for auction. At the table, where the old woman discusses the sale of the house with an agent, a tear-soaked handkerchief held to her eyes, a newspaper lies open at a page marked 'Apartments'. The unconcerned bravado of the father makes explicit where the fault for this reversal of fortune lies. He stands as the male equivalent of the fallen woman, although his sin is a social rather than sexual one. He is a profligate, who has neglected his familial responsibilities and squandered his fortune on drink and gambling. A racing notebook is held in his left hand and a print of a horse and jockey lies conspicuously against a cupboard marked '1648', this print's contemporaneity contrasting sharply with the old master portraits of the family, one of which is inscribed with the name 'Holbein'.

The sheer number of symbols that direct the viewer to this pictorial story was criticised by one reviewer, who argued that, although it was 'capitally painted', it was 'somewhat frittered away by trivial detail'. Even the heavy and ancient surround of the fireplace, the signifier of Victorian domesticity, is overloaded with symbolic details like the family coat of arms, which is repeated on the window, and a carving of Eve's temptation. The location of this carving just above the figure of the defenceless wife, however, serves only to emphasise the fault of the man and the effects of his actions on the rest of the family. Indeed, it could be said that this picture condemns a situation that renders women wholly reliant on the moral and financial worth of men and unable to avert such ruin. The wife's weary gesture, her arm outstretched in an attempt to counteract her husband's corrupt influence over his son, suggests that this is an appeal that has often been made, but to no avail. The vulnerability of the wife is repeated in the figure of the little girl, who looks pitifully at her grandmother and holds tight a doll, as if afraid that it too will be marked up for sale.

As well as its significance for gender politics, Martineau's painting also has implications for class. By suggesting that this family belongs to the upper classes, the picture presents an attack on this particular section of society that sets it alongside the political writings of John Stuart Mill, or Thomas Carlyle, who argued in *Past and Present* that a 'High Class without duties to do is like a tree planted on precipices; from the roots of which all the earth has been crumbling'. In the decade that it took Martineau to complete this picture there were some notorious cases of wealthy men who had spent their life in indolence and wasted their fortunes in gambling and luxurious lifestyles. Perhaps the closest analogue comes in the figure of the second duke of Buckingham, whose lavish tastes and corrupt habits caused him to amass a debt of a million pounds. In 1847 the bailiffs took possession of his effects. Some of his estates were sold and a forty-day sale, attended by dealers from all over the world, auctioned off pictures, china, plate and furniture from his mansion at Stowe. The event was well publicised and the contents of the sale described in some detail by journals like the *Athenaeum*. Martineau might well have had this incident in mind when he was working

on the painting. *The Times* reported that Buckingham was 'a man of the highest rank, and of a property not unequal to his rank, who has flung away all by extravagance and folly, and reduced his honour to the tinsel of a pauper and the baubles of a fool.' Perhaps it is no coincidence that the frame of *The Last Day in the Old Home* is decorated with a victor's laurel and a fool's cap and bells, along with the dates 1523 and 1860, the period of the family's rise and fall. The Duke of Buckingham died a ruined man in 1861, the very year that Martineau was achieving such success with his picture at the Hogarth Club.

Past and Present 1858

Tate

Exhibited in the Royal Academy in 1858, this triptych originally had no title but was accompanied in the catalogue by a fictional diary entry:

> August the 4th. Have just heard that B– has been dead more than a fortnight, so his poor children have now lost both parents. I hear *she* was seen on Friday last near the Strand, evidently without a place to lay her head. What a fall hers has been!

The picture shows the discovery and outcome of a wife's adultery, an unsavoury subject which might account for the fact that the painting remained unsold in the artist's studio until after his death. Some critics even regarded *Past and Present* as unsuitable for public display. The reviewer in the *Athenaeum* described it as 'an impure thing that seems out of place in a gallery of laughing brightness, where young, unstained, unpainted and happy faces come to chat and trifle'. But the picture was of contemporary relevance, painted in the light of the Matrimonial Causes Act of 1857 that legalised the sexual double standard by allowing wives to be divorced for adultery alone, while a husband's infidelity had to be accompanied by another offence such as incest, bigamy, cruelty or desertion. Symbols are used extensively in the 'discovery scene' which would have been the central picture of the triptych. The woman's punishment, her eviction from respectable society, is indicated in the open door reflected in the mirror, while her fall is accompanied by the collapse of the house of cards that her daughters are constructing, a didactic reminder of the ways in which her transgression destroys the middle-class home. Significantly, the house of cards is itself built on an unstable foundation: a book by the French author Honoré de Balzac. During the nineteenth century the French novel was a familiar signifier of corruption and impurity. Hippolyte Taine commented on the way that Balzac was vilified by the English. 'A book like Balzac's *Physiologie du mariage* would shock the public enormously, and the society for the repression of vice

would perhaps take action against it; but probably it would not have found a publisher. As for our ordinary novels, a liberal periodical, *The National Review*, cannot find words strong enough in which to condemn them – "Ignominy without name, the morals of petty speculators and women of the streets".'

Thackeray draws on this connection in *The Newcomes* (1853–5), where Lady Clara's avid reading of French fiction anticipates her adulterous elopement. Indeed, Thackeray's novel provides a parallel to the story told in Egg's painting. When Clara's cuckolded husband sues for divorce his lawyer describes a picture of corrupted marital bliss that is strikingly similar to that presented in *Past and Present*: 'with what pathos he depicted the conjugal paradise, the innocent children prattling round their happy parents, the serpent, the destroyer, entering into that Belgravian Eden; the wretched and deserted husband alone by his desecrated hearth'. Egg's painting also associates the adulteress with Eve: it refers in the catalogue to her 'fall', pictures her alongside an apple, and places a picture of the expulsion from Eden above her miniature portrait. Sympathy for the husband is secured in the print on the other side of the mirror: *The Abandoned*, a picture by the marine painter Clarkson Stanfield that had been exhibited in the Royal Academy in 1856 and shows the broken hulk of a ship tossed about on a rough sea.

Despite its elaborate symbolism, however, the triptych's narrative is far from transparent. Many reviewers were perturbed by the fact that there was no reason given for the adulterous act and they attempted to fill in the gap themselves. In a letter to a friend, John Ruskin blamed the circumstances on the silliness of a wife, who had read too many romantic novels and been seduced by a sham count with a moustache! Another problem concerns the two young women in the second picture: the daughters, who are now approaching adulthood and living in penurious conditions. A clue to their situation was provided by fellow artist, William Holman Hunt, who commented: 'Upon

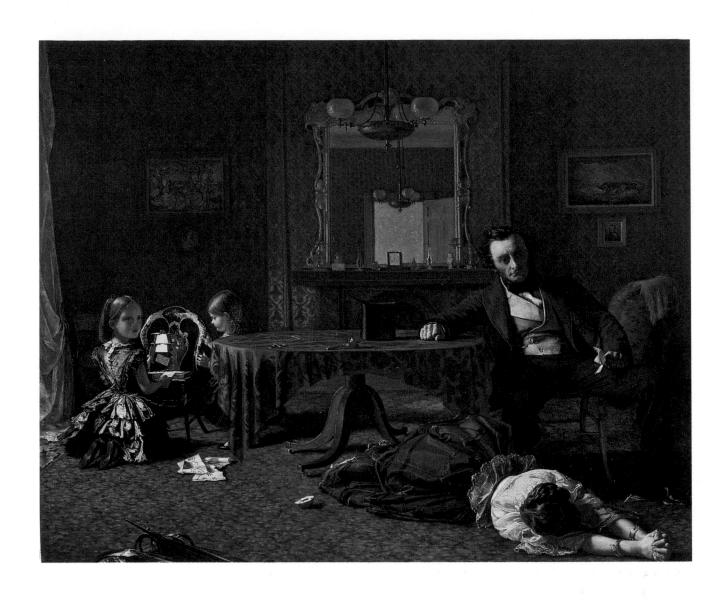

them too, the sin shall be visited ... for all their years to come.' Tainted with their mother's sin, the daughters are unable to fully occupy their place in society or to marry well. Indeed, the unfaithful wife's corrupt influence over her children was given legal precedence in the 1839 Infant's Custody Act, which refused a woman convicted of adultery access to or custody of her children. This is suggested in the catalogue description of *Past and Present*, where the daughters

are said to have 'lost both parents', despite the fact that their mother is still alive.

Egg's triptych does not easily condemn the adulteress, however. Rather, it is potentially subversive because of the very sympathy that it accords her. The last two paintings, depicting a simultaneous moment in time indicated by the identical moon, are perhaps the most problematic. As mother and daughters gaze longingly at the night sky, there is an implicit condem-

nation of the institutions that have separated them. Although the wife in the 'Present' is situated in squalid conditions, in an archway beneath the Adelphi, the traditional location for the outcasts of Victorian society, she appears almost as a Madonna figure, with a child in her arms and a lantern above her that looks, at first glance, like a star. The hulk of the ship represented in Stanfield's print makes another appearance here and implies that the woman is herself 'abandoned'. The posters behind her similarly stress her ambiguous position: they display the price and times of excursions to Paris and thereby define her as a conventional emblem of French immorality, but they also advertise Haymarket plays, Tom Taylor's *Victims* and Tom Parry's *A Cure For Love*, titles that suggest the adulteress's status as an object of pathos.

THOMAS WEBSTER
A Letter from the Colonies 1852

Tate

As emigration became increasingly popular, so did the rage for narrative pictures of the subject. Susan P. Casteras has pointed to over five dozen such images in the mid-nineteenth century. With the promise of what could be achieved in the colonies, emigration played on Victorian notions of self-help and the zeal for expansion, but it also meant a move away from other dominant ideologies like that of the home, and not simply in the sense of the domestic, familial space, but of Britain itself. The narrative painting attempts to lessen this contradiction, first by re-emphasising the place of the nuclear family and second by idealising the country left behind. This can be seen to great effect in Richard Redgrave's painting *The Emigrant's Last Sight of Home* (1859), where a departing family stop on top of a hill and look down the valley at the sun-drenched and seemingly prosperous rural community that they are leaving behind, prompting the question of why they have decided to emigrate in the first place.

Thomas Webster had himself 'migrated', though on a much smaller scale, when he moved his studio to the village of Cranbrook in Kent. Under his influence Cranbrook became an artist's 'colony', attracting the likes of J.C. Horsley, George Bernard O' Neill and Frederick Daniel Hardy, who set out to paint domestic scenes of village life. Kent itself, a largely agricultural community, had a rate of emigration that was above the national average, perhaps because a greater number of its emigrants were assisted to move by government grants. As early as 1841 it was reported that 652 residents had emigrated from the county in a five-month period. Popular destinations included the North American colonies, Canada, New Zealand and Australia. In Webster's picture the subject of emigration is introduced in a letter, a device familiar from pictures like Thomas Faed's *The First Letter from the Emigrants* (1849). Letters from emigrants were sometimes published in the press in an attempt to encourage moving to the colonies, and fictional epistles, though not always so enthusiastic, appear in the exhibition catalogues for Faed's *Sunday in the Backwoods*

(1859–63) and *The Last of the Clan* (1865). The letter was especially useful in such paintings because it allowed the absent parties to be evoked without necessarily having to be pictured. In Webster's image the significance of this particular missive is explained in the title of the painting. It elicits a variety of responses that are suggestive of the mixed public reaction to emigration itself, with the happiness of the man and eager anticipation of the young lady contrasting sharply with the concerned expression of the old woman. By picturing these different reactions the painting refuses to commend or criticise emigration and offers instead the possibility of both readings. But whatever news this letter might bring from abroad, it is the village that has been left behind that is idealised here, its informality and community spirit embodied in the bold figure of the postman, who leans through the window and manages to retain a smile, even though he is still waiting to be paid. The nurturing and safe environment that this home offers is suggested in the sapling plant that grows on the window sill underneath its protective glass cover, and the spatial relations of a room that is both snug and cosy while allowing the figures their personal space (even if this is achieved by positioning one figure through an open window).

Pictures of emigration are particularly effective in eliciting narrative tension; the gap produced between what is revealed and not revealed marks the most successful works in the genre. This painting is no exception. It stimulates the viewer's desire, inciting a search for meanings that ultimately remain elusive. What is the relation between the emigrant or emigrants and the family pictured here? Perhaps the silhouette on the wall provides a clue. To which colony does the title allude? What is the cause of emigration? What news does the letter bring? Good or bad? The sunlight that shines through the window tantalisingly illuminates the letter but steadfastly fails to illuminate its contents.

Death

I wage not any feud with Death
For changes wrought on form and face,
No lower life that earth's embrace
May breed with him, can fright my faith.
Tennyson, *In Memoriam*, 1850

Although symbols of death in Victorian narrative painting were highly conventional, they could also be manipulated in a number of new ways. The scythe, used to great effect in La Thangue's *The Man with the Scythe* (p.43), makes another appearance in Frederick Walker's *The Harbour of Refuge* (p.84) where the mower anticipates the imminent demise of the old folk who gather in the grounds of an almshouse. As in La Thangue's painting, the man with the scythe appears both as symbolic and incidental. Indeed, it seems that Walker did not initially regard this symbol as obvious enough and he shifted the mower from his position in the background of a preliminary study to the foreground in the oil painting. The scythe does not stand alone as a sign of death in this picture, however. Emblems of mortality emanate from the whole image, from its juxtaposition of the young and old woman to its fleeting images and brushstrokes. The artist's tendency to paint in fine, Pre-Raphaelite detail, which he then erased, gives a ghostly quality to this work, making it appear curiously airy and evanescent.

Walker is a striking example of the type of painter that Ruskin had referred to earlier in the century as 'poetical'. His friend and fellow artist, Hubert von Herkomer, identified his love of narrative as bound up in the representation of the natural world: Walker, he argued, 'felt all nature should be represented as a poem'. He seems to have achieved this aim in *The Harbour of Refuge*, where the blossoming cherry tree is not only beautifully rendered but, in its allusion to the coming of spring, draws attention to the cycle of life and death and the possibility of rebirth. The colours in this painting also assume a 'poetical' function, revealing a side of the artist not seen in his successful career as a black-and-white illustrator. As the reds and golds of the sunset engulf the rooftop of this grand building in an apocalyptic glow, there is the implication that the end of the day is also fast approaching for those who have found a momentary 'harbour' here. A biographer of Walker's, Clementina Black, was particularly impressed

HENRY WALLIS
Chatterton
detail (see p.85)

with the way that the colours of the painting seemed to take on a life of their own, illuminating the room where it hung in the Tate 'even in the closing twilight of a December afternoon'.

One of the most famous narrative images is Henry Wallis's *Chatterton* (p.85), where the ashen skin of the young man contrasts horribly with his strong and supple limbs. Born in 1752, Chatterton faked a number of medieval histories and poems under the name of Thomas Rowley, before harsh criticism and financial difficulties led him to commit suicide in London at the age of eighteen. The painting, although seemingly stark in its details, demands a narrative reading and Ruskin called on its spectators to 'Examine it well inch by inch' and 'Give it much time'. It was accompanied on the frame and in the catalogue by a quotation from Marlowe's *Dr Faustus*:

> Cut is the branch that might have grown full straight
> And burned is Apollo's laurel bough.

On the floor of the garret in which Chatterton lies are torn-up manuscripts, a copy of the *Middlesex Journal* to which he contributed, and the empty phial that contained the poison. Even his bright clothes carry nar-

FREDERICK WALKER
The Harbour of Refuge 1872
Tate Collection

Inspired by a group of elderly people whom Walker had seen sitting outside a church, the background of this scene was painted at Jesus Hospital near Maidenhead. Walker told the artist J.W. North that the man in black was how he imagined himself when old, but, tragically, he never reached this age. After a protracted illness he died aged just thirty-five.

rative weight, with the striking purple breeches that the poet wears and the blood red jacket with its yellow silk lining that he has thrown casually over a chair signifying the vanity that is said to have contributed to his death. Wallis sets the scene as dawn breaks over the dome of St Paul's and the tower of the Holy Sepulchre Church in Holborn. It is a new day that Chatterton will never see, his brief life embodied in a single rose that already sheds its petals on the window sill. From a dying candle set on a table in the corner, a fine wisp of smoke floats towards the open air, a symbol of the young man's departing spirit.

Another candle, flickering in the cool light of early morning, makes its appearance in Frank Bramley's *A Hopeless Dawn* (p.86). Here death appears indirectly, in its effects on the family. Bramley was a member of a group of painters who established themselves in the Cornish fishing village of Newlyn and often painted scenes of fishing life. Death at sea was a familiar narrative subject among these artists. Walter Langley, another inhabitant of Newlyn, had painted a similar scene in 1882 entitled *But Men Must Work and Women Must Weep*, where a young wife is comforted by

an old woman who looks anxiously from the cottage window. In the window of Bramley's painting a barometer and a bunch of seaweed hang forlornly as morning breaks over the icy blue sea. It is the visual effects here that tell the story, with the waves and clouds merging together and rising from the canvas in a swirling froth of paint that suggests the ferocity of nature. A large Bible lies open where the wife and an old woman (her mother or mother-in-law?) have been praying for the fisherman's return, but even this brings no comfort in the cold light of day. On the wall is a print of Raphael's cartoon of *Christ Giving the Keys to St Peter*, an image that bears out the fisherman's fate and divine salvation, and alludes to the extract from Ruskin's *The Harbours of England*, which was quoted in the exhibition catalogue:

> Human effort and sorrow going on perpetually from age to age;
> waves rolling for ever, and winds moaning, and faithful hearts

FRANK BRAMLEY
A Hopeless Dawn 1888
Tate

This picture established Bramley's reputation. It was the first painting of the Newlyn School to be purchased by the Chantry Bequest for the Tate.

right
FRANK BRAMLEY
A Hopeless Dawn
detail

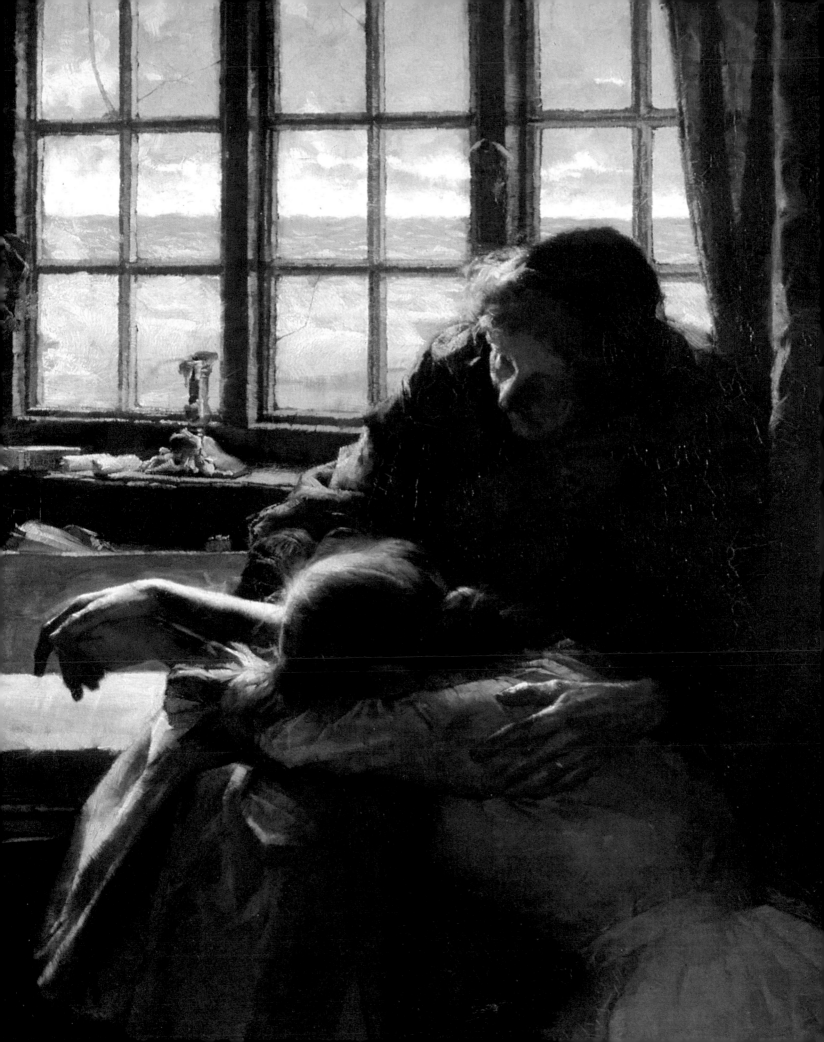

wasting and sickening for ever, and brave lives dashed away about the rattling beach like weeds for ever; and still, at the helm of every lonely boat, through starless night and hopeless dawn, His hand, who spreads the fisher's net over the dust of Sidonian palaces, and gave unto the fisher's hand the keys of the kingdom of heaven.

Paradoxically, *A Hopeless Dawn*, like other Victorian images of death, works against the onslaught of time to capture forever this fleeting moment. Whether they are set in garrets, lonely fishermen's cottages or the gardens of almshouses, these pictures display and subvert human mortality, providing in their canvases their own 'harbours of refuge', where death is both present and overcome.

GEORGE SMITH
The Soldier's Wife
detail (see p.93)

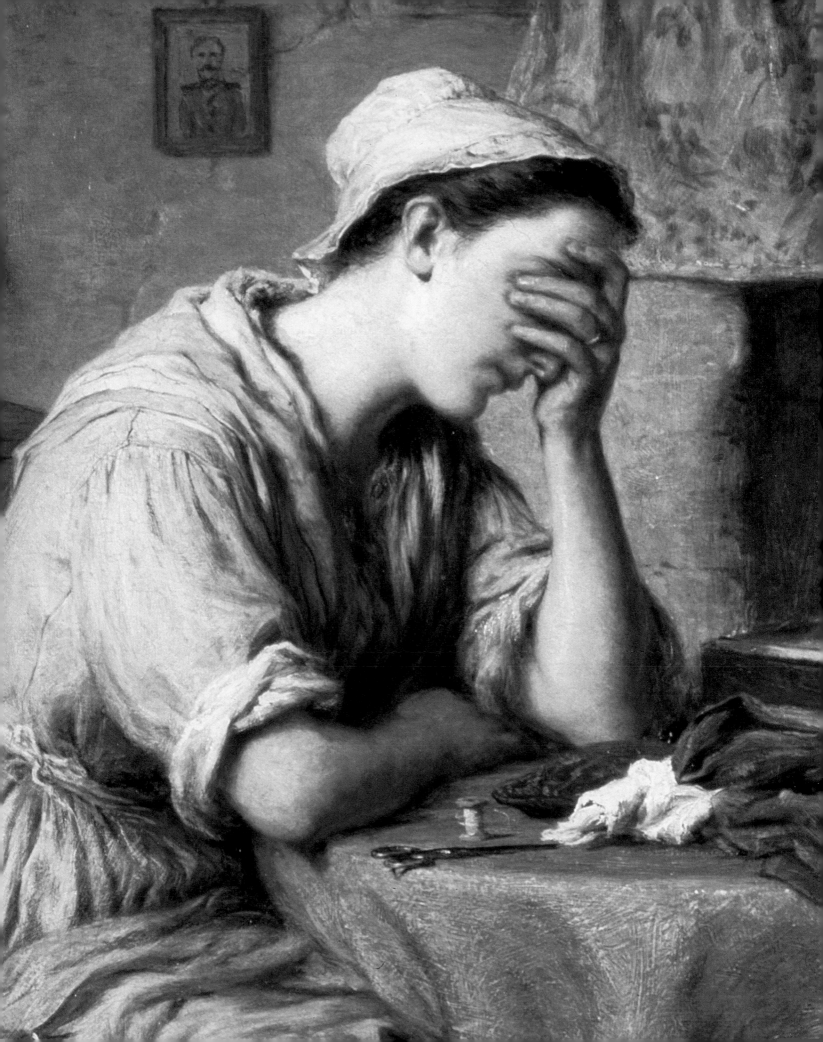

HENRY ALEXANDER BOWLER

The Doubt: 'Can these Dry Bones Live?' 1855

Tate

As a young woman leans over a gravestone in a country churchyard she stares at a skull and bones that have resurfaced in the soil beneath. Her doubt is that of the picture's title: confronted with such seemingly irrefutable evidence of human mortality, surely the belief in an afterlife seems impossible, even irrational.

This small canvas embodies the religious upheavals that transformed nineteenth-century Britain, and in particular it charts the emergence of agnosticism, a term that was coined by Thomas Huxley in the 1840s to describe the doubt in religious faith that arose from lack of empirical evidence. With the growth of the sciences, and especially of geology in the 1830s, Biblical ideas of creation were questioned, and scientific ways of seeing the world came to be regarded as the only truths. This painting, however, both raises a doubt and attempts to quell it. The indecisiveness of the title is counteracted by pictorial proof that these bones *can* live. The question that the lady asks and that forms the title of the painting is taken from the Book of Ezekiel in the Old Testament:

> The hand of the Lord ... set me down in the midst of the valley; it was full of bones. And he led me round among them ... and lo, they were very dry. And he said to me, 'Son of man, can these bones live?'

By quoting this passage, the picture anticipates the answer, which would have been familiar to most Victorian spectators: the bones, of course, start to rattle, acquire flesh, and are eventually resurrected. Bowler's painting might be less dramatic but is no less assured in its belief in an afterlife. This is indicated on the gravestone on which the woman leans, which belongs, significantly, to one 'John Faithful' and is inscribed 'I am the Resurrection and the Life', while to her left a horse-chestnut sprouts a shoot on a stone

engraved with the word 'Resurgam' (Latin for 'Resurrection'). A butterfly, the symbol of the soul, rests on the skull, while others flit amongst the tombs. The bright spring day and glorious colours in this picture also point to life rather than death, and this is emphasised in the attractive youthfulness of the woman and the brilliance of her costume.

This picture, then, attempts to instil religious confidence and faith in its spectators, but its outcome might have been rather different if it had been painted just three years later in the aftermath of the publication of Darwin's *Origin of Species*, which presented the most serious threat to Christian ideas in the nineteenth century, undermining not only Biblical accounts but the place of mankind within the universe. In Bowler's painting the threat of science is easily overcome; the woman's doubt is only momentary and will lead to a renewal and strengthening of her faith. Her uncertainty is itself presented as healthy and natural, a questioning that suggests, with Tennyson, that 'There lives more faith in honest doubt ... than in half the creeds'. Perhaps the most striking feature of this picture, however, is that its religious quest is undertaken by a woman, and one, moreover, who would seem more suited to the pages of a keepsake annual. With the liveliness of this girl's mind embodied in the vibrancy of the image, Bowler's heroine provides a refreshing contrast to patriarchs like Tennyson, Ruskin and Matthew Arnold, who expressed religious doubts throughout the century. This reversal of conventional gender roles was not lost on reviewers of the painting. The critic in the *Art-Journal* concluded that, although the picture was 'a most powerful work in many of the most valuable qualities of art', the question of its title 'should have been asked by a man' rather than a lady wearing a bonnet!

GEORGE SMITH
The Soldier's Wife 1878

Torre Abbey, Torquay, Devon

The subject matter of this painting and the ways in which it tells its story are reminiscent of those images that emerged in the heyday of the narrative picture almost two decades before. Certainly, paintings that showed the effects of war on the family were especially popular in the middle years of the century when the Crimean War and Indian Mutiny had provided a wealth of material for painters. A parallel but happier scene is depicted in Thomas Faed's *The Soldier's Return*, where, in place of Smith's concerned daughter, an injured soldier creeps through the door of a cottage, while his family, unaware of his entrance, continue to read about the progress of the war in the newspaper. In Smith's image the newspaper also has a prominent role, but here it seems only to have brought an account of the soldier's death and lies crumpled on the floor. These sad tidings are confirmed in the figure of the mother, who buries her face in her hand, while her three young children continue to play their game of soldiers, oblivious to what has happened or to the real horror that their game entails. An older child, an intuitive girl, who has just returned from shopping or work, immediately senses something amiss, and looks fearfully at her mother.

Smith's picture, while appearing as simply domestic in its interests, is highly political and problematic. It both glorifies war, using it as a subject for the painting, alongside symbols like the toy soldiers and the print of the Duke of Wellington that hangs conspicuously on the wall, and, by indicating its consequences for this poor family, also condemns it. In drawing attention to the simplicity of the cottage, the size of the family, and the clothes that the wife has recently been mending, the painting points to the future and asks how the mother will support her children if her husband is dead. Mementos of the absent soldier are everywhere, from the proudly displayed miniature of him in uniform that hangs under the picture of the Duke of Wellington, and the tobacco box and pipe perched on the shelf in the corner, to the empty chair by the fireside that awaits his return.

The precise nature of the 'future' elicited in the image, however, is highly ambiguous. The painting plays with the spectator's assumptions, leaving only a trail of unanswered questions. For one can never be certain what has happened to the absent soldier. After all, the title alludes to the woman as his 'wife' rather than 'widow'. How then is this image to be read? Is the soldier dead or alive? Is the wife's reaction indicative of shock or relief? The quotation cited in the exhibition catalogue intensified this uncertainty by suggesting that the wife herself does not know the fate of her husband:

> Mutely she sits, the soldier's wife;
> Her brave one's work is done;
> She only knows that in fierce strife
> The battle has been won.

While the account of the soldier's work being 'done' might allude to his death or the successful outcome of the mission, it is also unclear what battle this painting refers to. The period was full of campaigns and wars that allowed the bravery of British soldiers to shine precisely because they were so badly managed. Perhaps there is no historical analogue to this picture but it does anticipate the bloody Zulu war that broke out the year after Smith exhibited this painting. Intended to protect British colonial interests in West Africa, this conflict was tellingly described by one commentator as the 'widow-making war'.

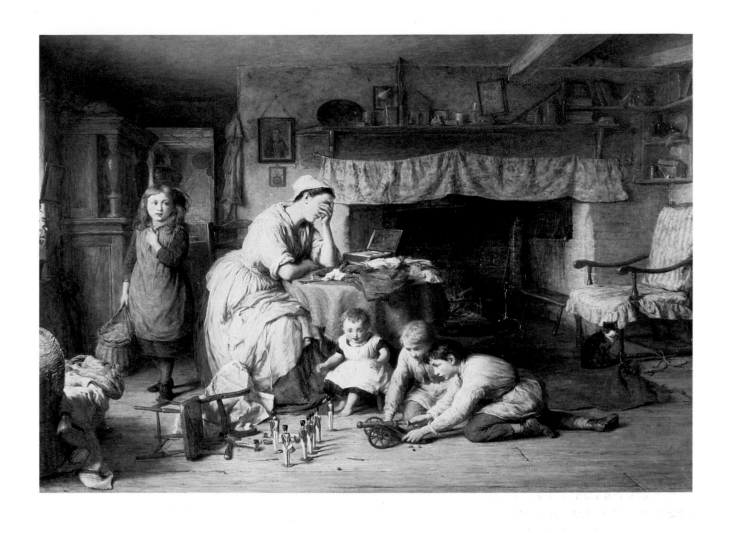

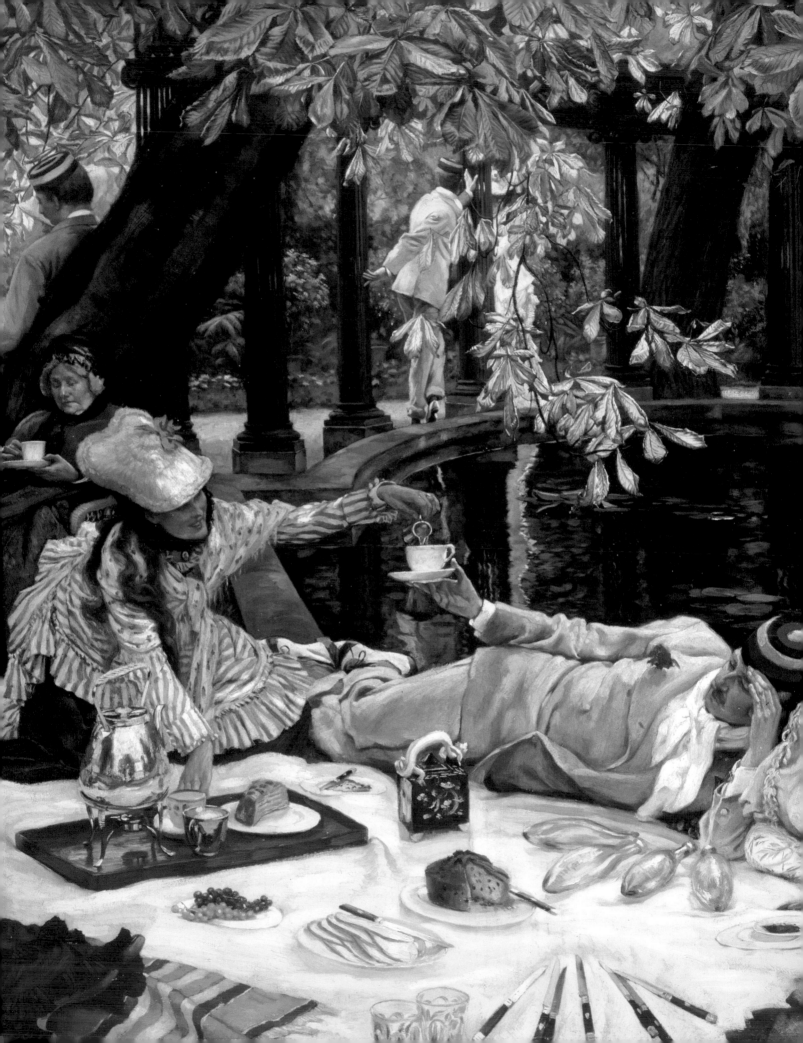

The End of the Story?

The demise of the narrative painting can perhaps be traced in the pictures of death themselves: the shift from the symbolism and finish of Bowler's *The Doubt* to the rough brushstrokes and atmospheric tones of Frank Bramley's *A Hopeless Dawn*. Although Bramley's picture still tells a story, it draws attention to itself and its own painterliness in a way that suggests the late nineteenth-century move towards Impressionism and Aestheticism. Earlier in the century the status of narrative painting as painting was often marginalised. Writing in 1855 at the time of the Exposition Universelle in Paris Richard Redgrave concluded that the most perfect execution in art 'is that which is least to be noticed, that calls least attention to itself'. This opinion was also held by Ruskin, who argued that it was the 'thought' or subject of the painting that was most significant; by themselves the technical mechanisms of a picture were unimportant.

The dispute between the old school of narrative painters and the new schools, which advocated the primacy of form over story, came to a head in 1878 when Ruskin was sued by James McNeill Whistler for the loss of earnings and reputation suffered when this most influential Victorian critic accused him of 'flinging a pot of paint in the public's face'. Stalwarts of the school of narrative painting were called to give evidence at the trial, among them Frith, who introduced himself as the 'author' of *The Derby Day* and concluded that there was nothing praiseworthy in Whistler's art. The tide, however, was turning. A decade later Frith's pictures were coming under attack, with R.A.M. Stephenson arguing that, although they were clever and full of interest, 'they have little to do with the art of painting'. Whistler, it seems, had won, and far more than the derogatory farthing that the judge awarded him in damages. His 'Ten O'Clock Lecture', delivered in February, March and April 1885, was a scathing attack on narrative art that criticised its attempt to teach the public and asserted instead that painting's goal was its own beauty and perfection. Whistler's pictures, as many of their titles indicate, have more affinities with music than with literature. The same is true of the work of artists like Rossetti, Albert Moore, Frederic Leighton and even Edward Burne-Jones, who in his later career renounced the idea that pictures should be read like poems.

The shift in priorities and styles that occurred at the end of the nineteenth century was not simply an aesthetic matter, however. Rather, it was bound up in the ideas of national identity that defined the Victorian nar-

JAMES TISSOT
Holyday
detail (see p.97)

rative painting. The genre, in its construction as 'British', had consolidated the growth of empire. But as the century drew to a close, foreign, and especially French, influences were coming to the fore. Not only were French painters such as James Tissot producing their own particular brand of narrative picture (seen in images like *Holyday*, p.97) but British artists were seeking their inspiration abroad, like Bramley and La Thangue who used chisel-shaped brushes in an attempt to emulate the 'square' block technique of the French painter Jules Bastien-Lepage. For earlier narrative artists like Frith these movements were almost incomprehensible. He regarded Impressionism, in particular, as 'bizarre', predicting, with some accuracy, that it would 'do incalculable damage to the modern school of English art'. But even he could not have imagined the full extent of narrative painting's decline.

By the turn of the century the demise of the narrative picture was well under way. When William Sharp reviewed the Victorian art world in 1902, narrative painters came in for his most scathing attack, their successes regarded with a mixture of curiosity and condescension:

> There is a radical tendency in the English art-world to value and
> certainly to care above all else for the work of the literary painter.
> Let a man tell a story well in illustration, or be obviously dramatic
> or humorous or fantastic, and he will be popular. It is the episode
> told or suggested in a graphic way which pleases the crowd ... There
> are other artists again who occupy the frontiers; that is, who are
> literary painters, in so far that the story-telling instinct is a
> dominant factor in their work, but who have in them much of the
> genuine painter so that we are often able to enjoy what they do
> simply as art, irrespective of the literary interest of the picture.

The 'Englishness' of narrative is now regarded with disdain rather than reverence. Moreover, as Sharp implies, the popularity of the pictorial story, its construction as a democratic genre, contributed to its downfall. Ruskin had himself equated popularity with vulgarity and this attitude intensified towards the end of the century, especially in Aestheticism, which prided itself on exclusivity and being above the 'common' taste. For Sharp, the popularity of the genre is presented as its weakness, a case of pandering to an ignorant public. The best paintings are those where the narrative is subordinate or accidental, where the story-telling takes second place to the brushstrokes or, preferably, where it is excluded altogether.

The objectivity of Sharp's assessment of the narrative picture is questionable, however, precisely because he judges it only according to the val-

JAMES ABBOTT MCNEILL
WHISTLER
Nocturne in Black and Gold: The Fire Wheel 1875
Tate

A similar painting of fireworks, *Nocturne in Black and Gold: The Falling Rocket*, was at the centre of the Whistler-Ruskin trial. The narrative painters called to give evidence failed to see what the picture was all about and the courtroom exploded into laughter when the Attorney-General asked Whistler how long it took him 'to knock off that nocturne'. Whistler's defence was that, although it had only taken two days to paint, it needed 'the experience of a lifetime'.

JAMES TISSOT
Holyday c.1876
Tate

Like earlier narrative paintings, Tissot's plays with the ambiguity of the relations between its central characters. It was painted in the garden of the artist's house, which was situated near Lord's cricket ground and shows the men wearing their cricket caps.

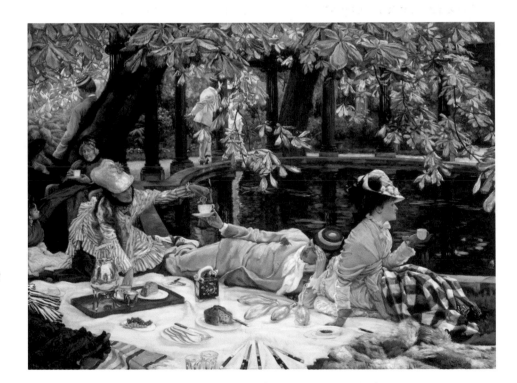

ues of paintings that emphasised the status of art as art rather than as a genre with its own set of codes and conventions. In this context the narrative picture always seems risible, a type of image that was hopelessly misguided in its aims and priorities. But the divide between subject and form that the genre was seen to embody is not always so self-evident. Not all the artists should be tarred with the same brush. For painters like Orchardson, Walker and Bramley, colour, tone and pattern were not subsumed by the subject matter but played a part in creating it, in telling the story. Such images expose the fact that even the narrative painting makes meanings in distinct ways from texts: in atmosphere, light, texture and spatial relations. It is these devices, indeed, that mark its difference from literature and call into question the definite shift between this type of art and later movements. After all, narrative pictures are there to be looked at as well as read, and they do not mask but often exploit this element in their decorative appeal. The gorgeousness of Bowler's *The Doubt* (p.91) or the glossy glare of Hunt's *The Awakening Conscience* (p.26) are not separate from but an inextricable part of the tales that they tell. This is not to say, however, that the amalgamation of looking and reading that the narrative image demands always leads to a unified or coherent practice, or to a tale that is completely told.

Select Biographies

These biographies cover the narrative painters who are discussed in most detail in the text. Artists' names in *italics* indicate separate biographical entries.

Henry Alexander Bowler
1824–1903

Born and educated in London, Bowler is mainly remembered as the artist of *The Doubt: 'Can These Dry Bones Live?'*, a painting that, in its subject matter and bright colours, betrays a Pre-Raphaelite influence. Bowler painted landscapes as well as narrative pictures but much of his career was devoted to teaching. From 1851 to 1855 he was headmaster of Stourbridge School of Art and went on to be a school inspector. Between 1861 and 1899 Bowler occupied the position of Professor of Perspective at the Royal Academy.

Frank Bramley
1857–1915

Bramley was a leading figure in the Newlyn School along with *Stanhope Forbes* and Walter Langley. Named after the Cornish village in which these artists were based, this School was characterised by depictions of fishermen's families, *plein-air* landscape painting and the use of square brushes. Such on-site work was undertaken in the hope of achieving a greater naturalism than could be attained by working in a studio. Bramley was a founder member of the New English Art Club but resigned his post in 1890 following a scathing attack on his work by Walter Sickert. Bramley was elected to the Royal Academy in 1911.

Emma Brownlow
1832–1905

Brownlow was brought up in the Thomas Coram Hospital for Children in London where her father was secretary. No doubt influenced as a child by the impressive collection of paintings in the hospital, she became an artist herself and worked in Belgium and France, often painting pictures with foundling themes. She exhibited under the name of Mrs E.B. King following her marriage in 1867 to Donald King, a theatrical singer, whom she met through the hospital choir. Her paintings are rich in narrative detail and display a particular fascination with children seen in images like *Granny's Lesson* and *Lullaby*.

Augustus Leopold Egg
1816–1863

Born in London, Egg was the son of a wealthy gunsmith and studied at Sass's Academy in 1834 and the Royal Academy schools in 1835. He was a founder member of The Clique, a group of artists including *William Powell Frith* and Richard Dadd, who in the 1840s and 1850s rebelled against the teachings of the Royal Academy. This early rebelliousness was later reflected in the fact that Egg was one of the first supporters of the Pre-Raphaelites. Although he was not a prolific painter (he exhibited only twenty-eight paintings in the Royal Academy in his whole career), his subjects were varied, ranging from Italian and historical scenes to illustrations from literature and narrative paintings of Victorian life such as *Travelling Companions* and *Past and Present*. No doubt he was influenced in these scenes by his literary friends. He was a close companion of Wilkie Collins and Charles Dickens, with whom he travelled abroad. Egg was elected to the Royal Academy in 1861. He died in Algiers in 1863.

Luke Fildes
1843–1927

Born in Liverpool, Fildes was adopted by his grandmother Mary Fildes, a political activist and leading figure in the Chartist movement. Her political and social interests are borne out in his own work. Fildes trained in Warrington School of Art before going to London in 1863 and entering the Royal Academy schools in 1866. He was one of the most successful illustrators of the period and worked for the magazines *Once a Week* and the *Graphic*. His first illustration for the *Graphic*, *Houseless and Hungry*, which was later turned into the oil painting *Applicants for Admission to a Casual Ward*, so impressed Charles Dickens that he asked him to illustrate *The Mystery of Edwin Drood*. In the 1870s Fildes turned to painting, often developing images that he had already produced in illustrations. As well as painting social realist pictures, he also depicted Venetian scenes and by 1900 was the most highly paid portrait painter in England. Fildes was knighted in 1906.

Stanhope Alexander Forbes
1857–1947

Forbes was born in Dublin and studied at Lambeth School of Art and the Royal Academy. He also trained in Paris where he was influenced by the French painter of peasants, Jules Bastien-Lepage. He adopted Lepage's ideals in the *plein-air* paintings that he produced as a member of the Newlyn School in Cornwall where he settled in 1884. Along with *Frank Bramley*, Forbes was a founder member of the New English Art Club. He married the painter Elizabeth Armstrong in 1889 and established a school of art with her at Newlyn. In the First World War Forbes was appointed an official war artist.

William Powell Frith
1819–1909

Born near Ripon in Yorkshire, the son of domestic servants, Frith moved with his family to Harrogate when he was seven. As a young boy he was coerced into painting by his parents, who sent him to Sass's Academy in 1835 and the Royal Academy schools in 1837. He stated that he wanted to be an auctioneer instead! Despite this inauspicious start, Frith went on to be one of the most successful artists of the nineteenth century. His fame was assured when he turned from historical and literary depictions to paint panoramic scenes of contemporary life. *Ramsgate Sands*, exhibited in 1854, was bought by Queen Victoria and became extremely popular, as did many of his other paintings, through the medium of engraving. Frith was elected a Royal Academician in 1853.

Frederick Daniel Hardy
1826–1911

The son of a musician, Hardy studied under *Thomas Webster*, who continued to be a major influence throughout his life, especially in his comic paintings of childhood. Between 1854 and 1875 Hardy was a member of the Cranbrook Colony in Kent, where his studio was in Webster's house, and he died in the village in 1911. The Colony was characterised by its depiction of rustic family scenes. Hardy exhibited his paintings at the Royal Academy and the British Institution.

William Holman Hunt
1827–1910

Born in London, Hunt started work at the age of twelve as a clerk. After painting in his spare time and studying at the British Museum and National Gallery, he entered the Royal Academy schools on his third attempt in 1844. There he met Dante Gabriel Rossetti and John Everett Millais and together they went on to form the Pre-Raphaelite Brotherhood. Hunt's narrative paintings come in many forms, from scenes of contemporary life to the Biblical subjects that he produced following his frequent trips to the Middle East. Never elected to the Royal Academy, Hunt ceased to show his work there after 1874, and exhibited instead in the Grosvenor Gallery and the New Gallery. He was awarded the Order of Merit in 1905.

Robert Braithwaite Martineau
1826–1869

Martineau was born in London, where his father worked for the Court of Chancery. Educated at University College London, he had decided to pursue a career in law and was articled to a firm of solicitors but gave this up to study in F.S. Cary's Academy and at the Royal Academy where he won a silver medal for drawing from the antique. Martineau became a pupil of *William Holman Hunt* and the Pre-Raphaelite influence on his work is demonstrated in his historical and genre scenes. He shared a studio with Hunt until 1865 when he married Maria Wheeler. Martineau died of heart disease aged forty-three.

William Mulready
1786–1863

Born in County Clare, Ireland, Mulready was the son of a leather breeches maker. The family came to London before Mulready was five and he entered the Royal Academy schools at the age of fourteen. After experimenting with landscapes and historical subjects, Mulready found his niche painting anecdotal scenes that drew on seventeenth-century Dutch genre pictures. His influence on the development of Victorian narrative painting was considerable, not just in terms of subject but of technique too. His method of painting on a white ground, thus producing bright colours, was later adopted by the Pre-Raphaelites. Mulready's love life was almost as colourful as his paintings and he pursued a number of relationships following a separation from his wife, the sister of the water-colour painter, John Varley, after just six years of marriage. Mulready was also an accomplished illustrator and has the credit for designing the first pictorial envelope to be issued by the Post Office.

George Bernard O'Neill
1828–1917

O'Neill was born in Dublin and little is known of his life, but he specialised in small narrative scenes of children which were frequently exhibited at the Royal Academy. He was a member of the Cranbrook Colony in Kent along with *Thomas Webster* and *Frederick Daniel Hardy* and, like them, painted many idealised pictures of rural communities.

William Quiller Orchardson
1832–1910

Born in Edinburgh, the son of a tailor, Orchardson attended the Trustees' Academy in Edinburgh from 1845. He moved to London in 1862 and exhibited his first painting in the Royal Academy in 1863. His early penchant for literary subjects gave way in the 1870s to the theatrical dramas of upper-class life for which he is renowned today. He also contributed as an illustrator to the magazine *Good Words*. Orchardson married Ellen Moxon in 1873 and was elected to the Royal Academy four years later. He was knighted in 1907.

Richard Redgrave
1804–1888

Redgrave began work as a clerk and draughtsman in his father's office and entered the Royal Academy schools in 1826. He was one of the first artists to depict contemporary Victorian subjects and to emphasise what he called 'the trials and struggles of the poor and the oppressed'. His pictures display a penchant for story-telling that is seen to great effect in two of his most famous images, *The Governess* and *The Sempstress*. Much of Redgrave's career was devoted to administrative duties. He was Keeper of Paintings at South Kensington Museum, Inspector of the Queen's Pictures, and a member of the executive committee of the British section of the Paris exhibition of 1855. Redgrave was elected a Royal Academician in 1851 and offered a knighthood in 1869, which he declined.

George Smith
1829–1901

Little is known of Smith's life other than that he was a pupil of the Royal Academy schools and the painter Charles West Cope. He seems to have been influenced by Cope's genre scenes of mothers and babies, and excelled in domestic pictures, especially of children. Following the tradition of *Thomas Webster* and *Frederick Daniel Hardy*, Smith's genre paintings are rich in narrative detail.

John Roddam Spencer Stanhope
1829–1908

Stanhope was a pupil of the painter G.F. Watts and was especially influenced in his allegorical subjects by Edward Burne-Jones. The Pre-Raphaelitism inherent in his work can be seen in subjects like *Thoughts of the Past*, painted when Stanhope occupied a studio in the same house as Dante Gabriel Rossetti in Chatham Place, London. Stanhope painted frescoes at Marlborough School Chapel, the Oxford Union and the Anglican Church in Florence, where he moved in 1880. Stanhope's niece was the painter Evelyn de Morgan and she often visited him in Florence.

Henry Wallis
1830–1916

Wallis studied in F.S. Cary's Academy and was admitted to the Royal Academy schools in 1848. He also studied art in Paris at the *Académie des beaux-arts*. A friend of *William Holman Hunt*, Wallis was greatly influenced by the Pre-Raphaelites. As well as painting historical subjects he achieved success with social realist pictures like *The Stonebreaker*. Following the painting of his most famous image, *Chatterton*, Wallis eloped with the wife of the writer George Meredith, who acted as the model for the tragic boy poet, and she bore him a son in 1858. Wallis travelled to Italy and from 1879 to 1892 was Hon. Secretary of the Committee for the Preservation of St Mark's, Venice. Later in life he collected Italian, Egyptian and Persian ceramics and became an expert on pottery.

Thomas Webster
1800–1886

Webster was born in London where his father held an appointment in the household of George III. After showing a particular aptitude for music, he started his career as a singer in the Chapel Royal choir but soon turned to painting and became a student at the Royal Academy in 1821. His small pictures of childhood and country life, painted in the comic vein of *William Mulready*, secured Webster's popularity. In 1856 he moved to the Kent village of Cranbrook and established an artist's colony. He died there in 1886.

See *Frederick Daniel Hardy* and *George Bernard O'Neill*

David Wilkie
1785–1841

Born in Fifeshire, Scotland, Wilkie studied at the Trustees' Academy in Edinburgh and the Royal Academy schools in London. His pictures of Scottish life, drawing on genre paintings of the Dutch school, had a great influence on the development of narrative painting. His popularity was assured with the phenomenal success of *Village Politicians* exhibited in 1806, and in 1822 the first guard rail in the history of Royal Academy exhibitions had to be erected to protect *Chelsea Pensioners Reading the Waterloo Dispatch*. Following trips to Spain as a result of ill health, Wilkie's later works display a Spanish influence. He was knighted in 1836 and died in 1841 on his way back from a trip to the Holy Land.

William Lindsay Windus
1822–1907

Windus was a pupil of the Liverpool Academy, and encouraged the Pre-Raphaelites to exhibit their paintings in the city. His own pictures display the conversion to Pre-Raphaelitism that apparently occurred after he saw Millais's *Christ in the House of His Parents*. Windus's most successful painting, *Burd Helen*, was shown at the Royal Academy in 1856 and was highly praised by Ruskin, unlike his next important picture, *Too Late*, which Ruskin concluded was the work of a sick man. Following this criticism and the death of his wife, Windus produced only sketches and drawings.

Select Bibliography

Altick, Richard D., *Paintings from Books: Art and Literature in Britain, 1760–1900*, Columbus 1985.

Baudelaire, Charles, *The Painter of Modern Life and Other Essays*, trans. and ed. Jonathan Mayne, London 1964.

Bendiner, Kenneth, *An Introduction to Victorian Painting*, New Haven and London 1985.

Boase, T.S.R., *English Art, 1800–1870*, Oxford 1959.

Carlyle, Thomas, *Past and Present*, London 1843.

Casteras, Susan P. and Ronald Parkinson (eds.) *Richard Redgrave*, New Haven and London 1988.

Casteras, Susan P., "'Oh Emigration! Thou'rt the curse ...'' Victorian Images of Emigration Themes', *Journal of Pre-Raphaelite Studies*, 6:1 (November 1985), 1–23.

Conrad, Peter, *The Victorian Treasure-House*, London 1973.

Frith, W.P., *My Autobiography and Reminiscences*, 2 vols. London 1887.

Hadfield, John, *Every Picture Tells a Story*, London 1985.

James, Henry, *The Painter's Eye: Notes on the Pictorial Arts*, ed. John L. Sweeney, London 1956.

Lambourne, Lionel, *An Introduction to 'Victorian' Genre Painting*, London 1982.

Lambourne, Lionel, *Victorian Painting*, London 1999.

Lister Raymond. *Victorian Narrative Paintings*. London: Museum Press, 1966.

Maas, Jeremy, *Victorian Painters*, London 1969.

Meisel, Martin, *Realizations: Narrative, Pictorial, and Theatrical Arts in Nineteenth-Century England*, Princeton 1983.

Nochlin, Linda, *Realism*, Harmondsworth 1971.

Nunn, Pamela Gerrish, *Problem Pictures: Women and Men in Victorian Painting*, Aldershot 1995.

Palgrave, Francis Turner, *Essays on Art*. London and Cambridge 1866.

Parris, Leslie (ed.), *The Pre-Raphaelites*, exh. cat., Tate, London 1984.

Payne, Christiana, *Rustic Simplicity: Scenes of Cottage Life in Nineteenth-Century British Art*, London 1998.

Redgrave, F.M., *Richard Redgrave: A Memoir Compiled from his Diary*, London 1891.

Redgrave, Samuel and Richard, *A Century of Painters of the English School*, London 1866.

Reynolds, Graham, *Painters of the Victorian Scene*, London 1953.

Reynolds, Graham, *Victorian Painting*, London 1966.

Reynolds, Joshua, *Discourses on Art*, ed. Robert R. Wark, New Haven and London 1997.

Ruskin, John, *The Complete Works of John Ruskin*, 39 vols., ed. E.T. Cook and Alexander Wedderburn. London 1903-12.

Sharp, William, *Progress of Art in the Century*, London 1902.

Sitwell, Sacheverel, *Narrative Pictures*, London 1937.

Taine, Hippolyte, *Notes on England*, trans. W.F. Rae, London 1872.

Thackeray, William Makepeace, *The Paris Sketch Book and Art Criticisms*, ed. George Saintsbury, London, n.d.

Treuherz, Julian, *Hard Times: Social Realism in Victorian Art*, London 1987.

Treuherz, Julian, *Victorian Painting*, London 1993.

Waldfogel, Melvin, 'Narrative Painting', *The Mind and Art of Victorian England*, ed. Josef L. Altholz, Minneapolis 1976, 159–74.

Warner, Malcolm, *The Victorians: British Painting 1837–1901*, New York 1996.

Whistler, James McNeill, *The Gentle Art of Making Enemies*, London 1890.

Wood, Christopher, *Victorian Panorama: Paintings of Victorian Life*, London 1976.

Wood, Christopher, *Victorian Painters*, Dictionary of British Art vol.IV, London 1995.

List of Paintings

All works are oil on canvas unless otherwise specified.

ANNA BLUNDEN
'For Only One Short Hour' 1854
47 × 39.5 cm
Yale Center for British Art

HENRY ALEXANDER BOWLER
The Doubt:'Can These Dry Bones Live?'
exh.1855
61 × 50.8 cm
Tate

FRANK BRAMLEY
A Hopeless Dawn 1888
122.6 × 167.6 cm
Tate

EMMA BROWNLOW
The Foundling Restored to its Mother 1858
76 × 101.5 cm
Coram Foundation, London

PHILIP HERMOGENES
CALDERON
Broken Vows 1856
91.4 × 67.9 cm
Tate

AUGUSTUS LEOPOLD EGG
Past and Present 1858
Three canvases, each 63.5 × 76.2 cm
Tate

THOMAS FAED
Faults on Both Sides 1861
67.3 × 55.2 cm
Tate

LUKE FILDES
Applicants for Admission to a Casual Ward
1874
137.1 × 243.7 cm
Royal Holloway, University of London

The Doctor exh.1891
166.4 × 241.9 cm
Tate

STANHOPE ALEXANDER FORBES
The Health of the Bride 1889
152.4 × 200 cm
Tate

WILLIAM POWELL FRITH
The Derby Day 1856–8
101.6 × 223.5 cm
Tate

The Road to Ruin, Plate 1, 1878
Engraving on paper
Victoria and Albert Museum, London

FREDERICK DANIEL HARDY
The Young Photographers 1862
30.1 × 45.6 cm
Tunbridge Wells Museum

WILLIAM HOGARTH
A Rake's Progress (Plate 1) 1735
Etching and engraving on paper
Tate

FRANK HOLL
Hush! 1877
34.3 × 44.5 cm
Tate

Hushed 1877
34.3 × 44.5 cm
Tate

ARTHUR BOYD HOUGHTON
Volunteers 1861
30.5 × 39.4 cm
Tate

WILLIAM HOLMAN HUNT
The Awakening Conscience 1853
76.2 × 55.9 cm
Tate

HENRY HERBERT LA THANGUE
The Man with the Scythe 1896
167.6 × 166.4 cm
Tate

CHARLES ROBERT LESLIE
A Garden Scene 1840
30.5 × 40.6 cm
Victoria and Albert Museum, London

ROBERT BRAITHWAITE
MARTINEAU
The Last Day in the Old Home 1862
107.3 × 144.8 cm
Tate

JOHN EVERETT MILLAIS
The North-West Passage 1874
176.5 × 222.2 cm
Tate

WILLIAM MULREADY
The Last In 1834–5
Oil on mahogany
62.2 × 76.2 cm
Tate

GEORGE BERNARD O'NEILL
The Foundling 1852
69.8 × 119.4 cm
Tate

WILLIAM QUILLER
ORCHARDSON
The First Cloud 1887
83.2 × 121.3 cm
Tate

RICHARD REDGRAVE
Country Cousins ?1847–8
Oil on paper mounted on canvas
82.5 × 107.3 cm
Tate

The Outcast 1851
78.7 × 104.1 cm
Royal Academy of Arts

The Sempstress 1846
62.2 × 75.6 cm
Forbes Magazine Collection, New York

GEORGE SMITH
The Soldier's Wife 1878
98 × 136 cm
Torre Abbey, Torquay

JOHN RODDAM SPENCER
STANHOPE
Thoughts of the Past exh.1859
86.4 × 50.8 cm
Tate

JAMES TISSOT
Holyday c.1876
76.2 × 99.4 cm
Tate

FREDERICK WALKER
The Harbour of Refuge 1872
116.8 × 197.5 cm
Tate

HENRY WALLIS
Chatterton 1856
62.2 × 93.3 cm
Tate

EDWARD MATTHEW WARD
The South-Sea Bubble, a Scene in 'Change Alley in 1720 1847
129.5 × 188 cm
Tate

THOMAS WEBSTER
A Letter from the Colonies 1852
Oil on wood
41.3 × 52.1 cm
Tate

JAMES ABBOTT MCNEILL
WHISTLER
Nocturne in Black and Gold: The Fire Wheel 1875
54.3 × 76.2 cm
Tate

DAVID WILKIE
The Blind Fiddler 1806
Oil on mahogany
57.8 × 79.4 cm
Tate

The Village Holiday 1809–11
94 × 127.6 cm
Tate

WILLIAM LINDSAY WINDUS
Too Late 1858
95.2 × 76.2 cm
Tate

Index

Photographic Credits